GHOSTS AND LEGENDS OF
LAKE
CHAMPLAIN

THEA LEWIS

Haunted
America

Published by Haunted America
A Division of The History Press
Charleston, SC 29403
www.historypress.net

Cover photo courtesy of Barb Kittell.

First published 2012

Manufactured in the United States

ISBN 978.1.60949.729.3

Library of Congress Cataloging-in-Publication Data

Lewis, Thea.
Ghosts and legends of Lake Champlain / Thea Lewis.
pages cm
Includes bibliographical references.
ISBN 978-1-60949-729-3
1. Ghosts--Champlain, Lake--Anecdotes. 2. Ghosts--Champlain, Lake, Region--
Anecdotes. 3. Parapsychology--Champlain, Lake--Anecdotes. 4. Parapsychology-
-Champlain, Lake, Region--Anecdotes. 5. Legends--Champlain, Lake. 6.
Legends--Champlain, Lake, Region. 7. Champlain, Lake, Region--Social life and customs-
-Anecdotes. 8. Champlain, Lake, Region--Biography--Anecdotes. 9. Champlain, Lake,
Region--History, Local--Anecdotes. I. Title.
BF1472.C55L38 2012
133.109747'54--dc23
2012029930

CONTENTS

ACKNOWLEDGEMENTS

T ell some people you're writing a book about ghosts, aliens and Bigfoot, and they'll laugh you right out of town, so I'm especially grateful to the people who have helped make this book possible.

First of all, I could not have completed this book without a handful of ladies I've never met. Patricia Kulman Samuelson and Deborah Eaton Adsit provided family history to a stranger who wrote them out of the blue, and Pauline Cray at the Back Inn Time in St. Albans went out of her way to honor my frantic last-minute photo request.

Gratitude and kudos go to Walter N. Webb for his thoughtful, illuminating account of the famous Vermont alien abduction in his book, *Encounter at Buff Ledge*, and a big shout out is due to Dr. Mark Rodighier at the J. Allen Hynek Center for UFO Research, for connecting the dots around Vermont UFO cases.

Thanks are also due to historian James P. (Jim) Millard, for sharing his knowledge of lake history, and to Gloria DeSousa and Matt Borden, my partners in crime at Vermont Spirits Detective Agency, for sharing their stories.

Historians David Blow and the late Lillian B. Carlisle were, as always, my first source and my guardian angel where Burlington history and lore are concerned, while my friend, the intuitive Nan O'Brien, was the calm voice that answered my "tour guide's intuition," her insights regarding those who've passed into spirit providing daily context.

ACKNOWLEDGEMENTS

Literary hugs to Charlie, Ernie and Lisa at radio station WVMT, for helping me spread history and for sending new information my way via their listeners, and to my artist buddy Justin Atherton, who turned out to be the fastest pen in the East. Finally, I couldn't make a move without my great friend and constant cheerleader Jean O'Sullivan; my daughter and daily wailing wall, Shannon Redmond; my son Anthony Dion, who has turned out to be pretty inspirational; and my three funny teenagers, Sam Lewis, Kylie Billings and Josie Lewis, who are good-natured even when I whine.

Last but not least, a world of thanks to my husband Roger, the Superman of this operation, who keeps me away from kryptonite and rescues me when I fall.

INTRODUCTION

Astrologically, I'm a Leo. It's a fire sign. So it comes as no surprise to me that playing in the water is not my cup of tea. But *living* by the water—that's another thing entirely.

As a teenager in the seventies, I was more than content to live in Southern California, cultivating my nonconformist persona in a town called Lompoc, just north of Santa Barbara. Our house wasn't far from the ocean, a fact I loved. Not as a swimmer: I barely passed the requisite dog-paddle test at my local high school. I'm no sun worshipper, either. My idea of fun at the beach is sitting beneath a wide umbrella with a frosty drink and a good book, which accounts for the fact that I've spent most of my life white as a ghostly sheet.

I loved the ocean simply for its beauty. Blue or green, serene or angry, under a calm cerulean sky or tempestuous clouds, the gigantic, undulating life force seemed both dynamic and romantic. When the fog settled in, I was reminded of scenes from *Jane Eyre* or the adventures of Gregory Peck's character, Captain Jonathan Clark, in the classic 1952 film *The World in His Arms*. Hey, I was the oldest child of a working single mom with four kids. I spent a lot of time reading and watching old movies on television.

One day, while listening to the radio station and grudgingly minding my three siblings who were arguing over a board game, I was drawn in by an on-air personality who claimed she could tell the future. I decided to call, and when I finally made it through the queue, she surprised me by telling me I would soon be traveling somewhere far away.

I explained I had no plans in the immediate future to go any farther than the location of my junior prom, happening in just a few weeks. But she persisted. I *was* moving, to a place by a large body of water.

I laughed. I already lived near a large body of water—the Pacific Ocean. I thought the woman was getting her wires crossed, and I told her so. She calmly replied that not only could she see me going but that once I got there, I would live in this place most of my life.

Two days later, my mother broke the news that we were moving back to her hometown of Burlington, Vermont. It was the place of my birth, too, loaded with aunts, uncles and cousins. But I was miserable at the thought. I hadn't been back to Vermont since I was a little kid. I was a California girl now, and I had sun-bleached hair to prove it.

Visions of Nanook of the north filled my head. What would I do in the cold and snow? What about my friends?

My buddies were sympathetic but also confused. When I told them where I was going, half of them thought Vermont was in Canada. The era was pre-Google, and I was too morose to bother asking about or researching the geography or amenities of my soon-to-be-new surroundings. I'm not proud to say I moped with a vengeance.

Finally, the time came to make the trip. Flying across the continent, I daydreamed while looking at clouds, bit my cuticles and grumbled to my sixteen-year-old self. Me in provincial New England? Me in tiny Vermont? Impossible. Ridiculous!

On the last leg of the journey, resigned to my fate, I was anxious while my plane made its descent. Finally, swooping down into the Champlain Valley, I saw it. Deep and mysterious, it sparkled like a giant sapphire between New York's majestic Adirondacks and Vermont's signature Green Mountains. It was smaller by far than the ocean I was used to, but magnificent, beautiful and blue.

It was Lake Champlain. Our "midland sea."

And somehow, I knew I was home.

That was in 1975, and true to what the radio medium said all those years ago, with only a brief hiatus in the late seventies, I have lived near Lake Champlain since. Its shores are where I walk my dog, connect with neighbors and do some of my best thinking.

Through my haunted tour, Queen City Ghostwalk, and my first book for The History Press, *Haunted Burlington: Spirits of Vermont's Queen City*, I've been able to pass along stories of the quirky characters who walked Burlington's streets many years ago and of their ghosts who seem to want to linger.

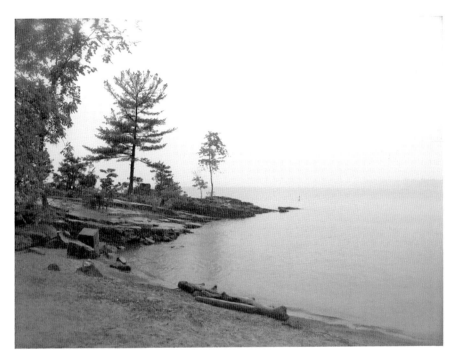

Cove at Oakledge Park, Burlington, Vermont. *Photo by Roger Lewis.*

In writing this book, I have been able to explore strange and chilling tales from both sides of Lake Champlain and more: Native American legends, spirits that have survived centuries and creatures not of this planet. It's been a fascinating trip. I hope you enjoy the ride as much as I have.

Chapter One

FRIGHTENERS OF THE FORT

If, like me, you like your history mixed with a ghostly tale or two, you'll love New York's Fort Ticonderoga. This scene of some of the bloodiest battles in American history before the Civil War is one of the most haunted attractions in the North Country and home to ghosts of all nations. American, French and British forces are still buried there. If the glowing orbs, eerie lights, strange whispers and full-body apparitions reported by people who work and visit Fort Ticonderoga are any indication, these characters from the past aren't shy about having their stories told.

Designed by military engineer Michel Chartier de Lotbinière and built by the French in 1755, star-shaped Fort Ti, as it's known to locals, was constructed at a critical point on Lake Champlain to keep the British from gaining military access to the waterway. Because French forts represented the king, they were usually more ornate in design than more utilitarian British forts of the day. Marquis de Lotbinière had never designed a fort before, but his first effort was impressive. With walls seven feet high and fourteen feet thick, surrounded by a five-foot-deep dry moat and a glacis, or sloping embankment, the fort contained barracks, storehouses and, in one of the bastions, a bakery that produced sixty loaves of bread a day for the soldiers quartered there. It was a stronghold that changed hands many times, and each new occupation took its psychic toll. Murders, executions, spurned lovers, suffragists—all have left their mark on Fort Ticonderoga. In 2009, The Atlantic Paranormal Society (TAPS) documented the strange phenomena at the historic landmark. Presenting their findings, investigator

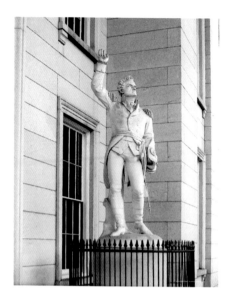

Ethan Allen imagined at Fort Ticonderoga. *Courtesy National Archives.*

Jason Hawes stated, "I firmly believe you have paranormal activity going on here."

Trisha Melton, a Fort Ticonderoga employee, agreed. She called the old fort "a very haunted place," confirming that people have seen glowing red orbs floating in some of the rooms. Steve Teer, who works on the museum's maintenance staff, said that one night, he spotted a strange red ball of light while working on the second floor of the South Barracks. The ball of light hovered in the air, just above his head. A co-worker who had come upstairs saw it too. "What do you suppose that is?" the man asked. As he spoke, the light whizzed away, disappearing into an air vent. From outside the building, people have spied a figure wearing a red coat standing in an upstairs window, and event coordinator Babette Props Treadway saw a figure in eighteenth-century dress wearing a large hat peering at her from the attic. One evening, after hours, two employees saw a figure in military attire go up the stairs to the second floor. They decided to split up, each taking one of the two stairways, so as not to lose the individual. When they both reached the landing at the top, there was no one there and no other exit. The French ovens, a cluster of caves beneath the fort, is rumored to have seen at least one murder, and people have heard low voices whispering in French. Some have smelled bread burning, and others have felt the sensation of falling or being pushed.

Outside, there have been numerous reports of the sound of footsteps emanating from the exterior stairs and smoky forms that take human shape and then disappear through solid walls. At the gatehouse, people claim to hear the spirit of a woman crying, and in the Garrison Cemetery, visitors have claimed to have seen horses with and without riders. Others have heard the sound of hoofbeats, though no horses are kept on the property. The mournful sound of bagpipes has been heard on the museum grounds, as well as the sound of drumbeats, as though some far-off regiment is being called to battle.

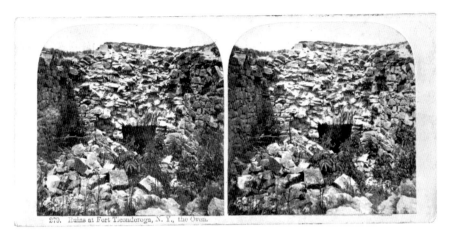

Stereoscopic view of Fort Ticonderoga ovens. *Image courtesy of Wikipedia.*

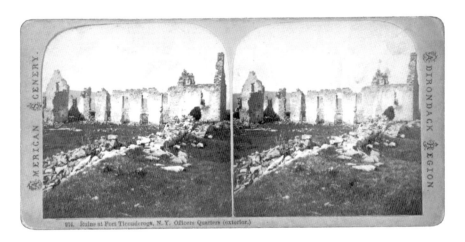

Ruins at Fort Ticonderoga. *Image courtesy of Wikipedia.*

Fort Ticonderoga is a place where full-body apparitions abound. There is the ghost of Mad Anthony Wayne, which has been spotted in more than one location. Near the fort and at the water's edge, you might spot his paranormal paramour, Nancy Coates. There is the Scottish ghost of Duncan Campbell, too, along with the more modern ghost of Sarah Pell, who lived at Fort Ti in the 1920s and '30s.

Sarah Gibbs Thompson Pell, a noted member of the women's suffrage movement, and her husband, Stephen Hyatt Pelham Pell, owner of a coffee, cotton and stock brokerage firm, were responsible for the early restoration

of Fort Ticonderoga. Stephen, whose great-grandfather, William Ferris Pell, had purchased the property, visited Fort Ticonderoga as a boy and was impressed by its history and its artifacts. He pledged that he would one day restore the place. In September 1908, he attended a press clambake hosted by the Ticonderoga Historical Society to talk up the idea of having the federal government purchase the Garrison Grounds from the Pell family. His wife and her father, Colonel Robert Means Thompson, were on board, with Means supplying the initial funding for the restoration, which became known as "Sarah's Project."

Today, Sarah's likeness can be observed meandering on the porch of the Pavilion, which is the site of the old Pell Estate and hotel. She has also been spotted in an upstairs window, gazing down at the plot known as the King's Garden.

GETTING THERE:

Fort Ticonderoga is located in the picturesque Adirondack Park on Lake Champlain and includes a prime view of Vermont's gorgeous Green Mountains.

From U.S. Interstate 87 (North or South): Take Exit 28 onto NY Routes 22 and 74 East. Turn left onto Route 74 East. Fort Ticonderoga will be on the right.

From NY Route 9-N (North or South): Follow 9-N to the traffic circle in the town of Ticonderoga. Turn east onto Montcalm Street and continue three miles through two stoplights and one flashing light onto Route 74 East. Follow for about a half mile, and the entrance to Fort Ticonderoga will be on the right.

From Vermont: Follow State Route 74 West to the Ticonderoga Ferry (toll ferry) at Shoreham or Route 22A via Route 73 in Orwell. After crossing Lake Champlain, the main entrance to the fort will be one mile ahead on the left.

Call: 518-585-2821
fortticonderoga.org

Chapter Two

MAD ANTHONY WAYNE

On the lakeshore by Fort Ticonderoga, a pale spirit waits. You may encounter her running along the water's edge, her cheeks wet with tears, or see her floating face-down in the shallows of the lake. She is Nancy Coates, the famous victim of a tainted love affair with Mad Anthony Wayne.

The jury is out on just *how* mad Mad Anthony Wayne was. It is written that Major General Wayne (his military title) had a fiery temperament but was a brilliant strategist and cool in battle. History also tells us he took care of his men and was highly regarded by them. Muster rolls of the Pennsylvania line, a formation within the Continental army, show soldiers repeatedly returned to fight under him. Even Native American scouts sent to spy on him were admiring, calling him "The Chief Who Never Sleeps."

Sane or not, he was always a challenge. He made his own rules and had a mind of his own. When he was just a boy, he was sent to his uncle, Gabriel, who was supposed to oversee his education. Not long afterward, Gabriel wrote to the boy's father, saying he was sorry, but he was afraid that young Anthony would amount to nothing.

"I really suspect that parental affection blinds you, and that you have mistaken your son's capacity," the letter said. "What he may be best qualified for, I know not." In hindsight, his uncle's letter was like an omen. He continues: "One thing I am certain of, he will never make a scholar, he may perhaps make a soldier. He has already distracted the brains of two-thirds of the boys under my charge by rehearsals to battles, sieges, etcetera." After some tough love from his father, Wayne's interest in academics

improved. He was especially good at math, and he became a surveyor, married and had nine children. But after a while, farm life and local patriotic pursuits weren't enough, since, at his core, Anthony Wayne was a military man.

Eventually, he recruited and organized the Fourth Pennsylvania Battalion of Continental troops and saw active service commanding his brigade during the retreat of Benedict Arnold. It was at that time, while in command at Fort Ticonderoga, that he met a widow, Nancy Coates.

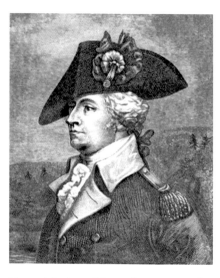

General Anthony Wayne. *Image courtesy of Wikipedia.*

Nancy Coates was a local woman. She was young, witty, attractive and known by the soldiers to be very generous with her attention. But even while she passed the time with a handful of enlisted men, her eye was on Anthony Wayne. Wayne found her pretty and charmingly unpredictable, a welcome distraction from the rigors of his command.

But not long after, Penelope Haynes came along. Haynes was the daughter of a Vermont landowner. She was beautiful, rich and younger than the widow Coates. She wasn't interested in any sexual shenanigans outside of marriage, but she had a bit of a crush on Wayne and loved to tease and flatter him. Nancy Coates, meanwhile, was completely smitten. She was spending less and less time in the company of other men and pressing Wayne for a commitment.

Even though it was whispered that Major Anthony Wayne had a wife back in Pennsylvania, both women vied for his affections. When the British began making military advances, General George Washington ordered Wayne to take troops, round up the community's women and weaker citizens and bring them inside the fort for protection. While he was away, people taunted Nancy Coates that he was off courting Penelope and might make her his bride that very day. When the troops returned later that night, Nancy saw Penelope at the head of the crowd, riding right beside Wayne.

Convinced the two *had* married and that her Anthony was lost to her forever, she became unhinged and made a grave mistake. She ran to the

lake and threw herself into the dark, cold water. Wayne and Penelope had not advanced their relationship, but Nancy Coates drowned never knowing the truth.

Startled hikers have seen her ghost, its arms outstretched, on the wooded footpaths, and her moans have been heard by visitors and fishermen near the deep blue lake. Some have seen what looks like the lifeless form of a woman in a long dress floating face-down in the water, only to have it disappear before their very eyes.

Poor Nancy Coates. She's destined to live out eternity at Fort Ticonderoga without her one true love. Or is she?

It seems Mad Anthony Wayne's ghost also spends time at this familiar haunt. Even though he didn't die at Fort Ti, his ghost has been spotted there, beside a fireplace, drinking from a pewter mug. He's also been seen smoking and standing watch inside other chambers in the fort.

A SPOOKY SIDE STORY

In the northern part of Vermont, there is a place called Lake Memphremagog. They say Wayne, who once tracked in that part of the territory, still shows up now and then. The story goes that back in the 1700s, he and two Canadian guides were looking for some bald eaglets to train for hunting. They found two, and Wayne raised them, even hand-feeding them himself. As they grew, he became very attached to them, and while they lived, he insisted they go everywhere with him. His fondness extends beyond the grave. Many a local has been caught off guard by the specter of Mad Anthony Wayne dressed in the garb of a frontiersman, walking along the shores of the lake with his arms outstretched. On each hand he holds an eagle poised for flight.

Chapter Three

NO GOOD DEED GOES UNPUNISHED

One of Fort Ticonderoga's earliest and most famous ghost stories begins in the Scottish Highlands, at a place called Inverawe, west of Loch Lomond.

Duncan Campbell, Laird (Lord) of Inverawe, was tall and dark, with flashing eyes and a regal bearing. He was considered one of the most handsome men in the Western Highlands. He was a member of the Black Watch, Scotland's best-known regiment, and he had quickly risen to the rank of major. As the tale begins, Duncan, home in his castle, had just finished his supper and was enjoying the warmth of a crackling fire when, suddenly, there was a commotion. A stranger burst through the door and into the great hall. The intruder, his clothes torn and bloodied, rushed forward to place his hands on the hearthstone. Frantically, he explained that, in the midst of a skirmish, he had accidentally killed a man and needed Duncan's help. At that time, the unwritten law of the Highlands was that sanctuary must be given to any man who touches your hearthstone. "For God's sake, hide me!" the man begged. "Swear on your dirk you will not give me up!" Wary, but minding his conscience, Campbell swore, hiding the man in a secret chamber downstairs.

Later that evening, in the gathering mist, a band of men pounded at his castle door. From them, Campbell learned his cousin, Donald, a man who had been like a brother to Campbell, was the one the stranger had killed. He

sent the gang away without revealing his secret and, some time later, finally managed to fall asleep.

But as he tossed and turned during the night, Donald appeared to him in a dream, begging him to give up his murderer and, in doing so, avenge his death. Distraught, but resolute, Campbell said no. He would not break his oath to the man he harbored, even for a beloved member of his own clan.

The next night, the spirit appeared again. This time, he was more demanding. "Shield not the murderer!" he said. "Blood must flow for blood."

Campbell couldn't take it any longer. He hauled the killer out of his bed and traveled with him to a cave near Ben Cruachan, the high point of a ring of mountains known as the Cruachan Horseshoe. He promised to return with food and water. But when he arrived the next day, the cave was empty. The man had vanished.

That evening, his cousin's ghost appeared to him once more, saying, "Farewell Duncan, farewell, 'til we meet again at Ticonderoga." Ticonderoga? Duncan had no idea what it was.

In 1758, Campbell found himself and his regiment across the ocean in New York, planning to advance on New France, what is today known as Canada. One night, while eating and drinking with a group of officers, Campbell told them about the incident with the man who had killed his cousin and wondered if any of them had heard of this place called Ticonderoga. One of the men said he had. The place they would soon attack went by a name other than Fort Carillon. The Iroquois called the land "Cheonderoga," which meant the "place between two waters." The white man, often imprecise in the pronunciation of native language, called it "Ticonderoga."

Duncan realized his time was running out. His fellow soldiers tried to console him, saying the apparition was a nightmare or figment of his imagination. Some joked that the fort was actually called "Fort George." But Duncan knew better. "Ticonderoga!" he would exclaim. "How to explain it away? I never heard the name until a few weeks ago!"

The night before his final battle, Duncan Campbell's cousin appeared to him one more time to deliver a final farewell. By the morning of July 8, 1758, he was resigned. "I have seen him," he told his fellow soldiers. "This is Ticonderoga. I shall die today." Duncan went to meet his fate.

And an ugly fate it was. Brigadier Lord Howe, the head of Campbell's expedition, had been killed three days earlier. That left Colonel Abercrombie, a man who was more politician than soldier, to mount the invasion. Unfortunately, he didn't make up his mind how they would go about it until they got there. Under his command, the British delivered what has been

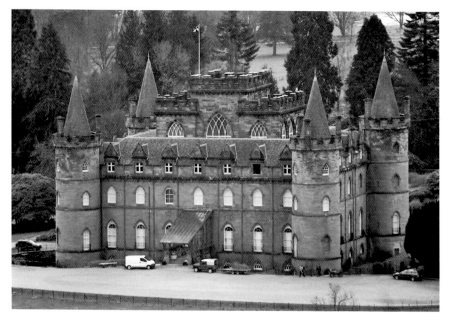

Inverawe Castle. *Image courtesy of Wikipedia.*

called one of the more bungled attacks in recorded history. By the time they arrived, the French had added another layer of fortification to their unfinished fort, an abatis made up of heavy logs, trees with the branches still on and sharpened spikes. Campbell's men got caught up in the barricades and became easy targets. In the mêlée, Major Campbell was wounded by a projectile from a French cannon, a mixture of shards of metal and broken glass. Blood poisoning set in, and he died nine days later at Fort Edward, in the home of distant relatives.

You would think that would be the end of the story, but there was more mystery to follow. Back in Scotland, on the day the Battle at Ticonderoga was taking place, renowned Danish physician Sir William Hart, along with a companion and his servant, was strolling around the castle Inverawe, Campbell's ancestral home. Hearing his friend gasp, Hart turned to see what was the matter. Looking up at the clouds, in the direction of his friend's pointing hand, he was astonished by a vision that seemed to depict Highland forces attacking the French, their efforts met with round after round of musket fire. He had no explanation for what he saw.

Later in the day, two sisters arrived at the castle with their own tale. They were crossing a bridge when one happened to look up. She shook

her sister's shoulder and pointed excitedly at what she saw in the clouds overhead. It looked like a battle going on in the sky. Banners in the colors of different regiments seemed to be flying, and two men, Major Duncan Campbell and his son John (who served with him), were shot down. Her sister saw it, too. As it turned out, there were more firsthand accounts of this strange phenomenon.

It was weeks until the official news arrived in Inverawe confirming the tale the pictures in the clouds had told.

Years later, we still puzzle over how it was possible.

Chapter Four

WHO'S HAUNTING HAWKINS HALL?

The original building of one of SUNY Plattsburgh's most happening haunts burned to the ground in 1929, but there are plenty of ghostly history and hijinks to go around at Hawkins Hall, the spirit's new stomping ground.

The original building on the site, called the Plattsburgh Normal and Training School, was built in 1890. It was intended as a two-year teaching and nursing institution and would eventually join the state university system. For the first few decades of its existence, the Normal School was, well, normal. But a chilly March evening in 1917 changed the mood to something quite paranormal.

James Atwood, the school's regular night watchman, had a lodge meeting to attend, so he asked the school's head janitor, a man named John Blanchard, to work his shift as a favor. The sixty-something Blanchard was well equipped to sub for Atwood. He knew the school like the back of his hand. After making the customary rounds to check that everything was secure, he settled in to the watchman's quarters for the night. Here's where the story gets interesting: At some point during the shift, for reasons still unresolved, John Blanchard sat himself down in a chair, wrapped a blanket around his face and, with his head resting on the desk in front of him, began inhaling illuminating gas from a tube. When assistant janitor Willard Parnaby arrived for his shift the next morning, he was nearly bowled over by the stench of gas. He investigated and found Blanchard seated but dead. He immediately notified the school's principal.

The question wasn't what had happened but why. Witnesses who were questioned after the fact said Blanchard had been acting strangely in the weeks before the incident, and Atwood told them the man had arrived to take the shift in his usual good spirits.

The quick answer would be that Blanchard had decided to take his own life, and the coroner did, in fact, rule the death a suicide. Blanchard's wife had died sometime before, and a beloved sister had passed away only recently. But there is another possibility. Blanchard could have been trying merely to pass the time, using illuminating gas as a recreational inhalant. Short-term effects of inhaling gas are euphoria, hallucinations and a state that is often compared to drunkenness. But misuse can result in accidental death.

According to a *Plattsburgh Sentinel* article dated March 16, 1917, the bed in the watchman's quarters was rumpled. Authorities speculated Blanchard had first turned on the gas and gone to bed but, fearing he wouldn't accomplish suicide, had gathered the blankets around him and placed the tube in or near his mouth. Perhaps it is just as likely that, with so much on his mind, he had hoped his inebriated state would ward off sleeplessness and get him through his shift. It would explain why, soon after Blanchard's passing, witnesses reported spotting a figure that eerily resembled him silently policing the upstairs halls. His apparition was seen near the flagpole on top of the building, too, looking over the edge of the roof.

It must have been frustrating for Blanchard living out the afterlife as an ineffectual sentinel and more than a little boring, because on January 6, 1929, trouble broke out where it often does in haunted schools—in the basement boiler room.

Here is the account from the *Syracuse Herald*:

SIX RESCUED IN PLATTSBURGH NORMAL FIRE.
TEACHER DROPS PUPILS FROM WINDOW TO GROUND.

Plattsburgh, Jan. 26—Fire believed to have started in the basement as a result of an explosion of an oil burning furnace destroyed Plattsburg Normal School yesterday noon with an estimated loss of $235,000.

The first alarm was sounded at 10:25 and upon the arrival of the local department the three-story brick structure was a mass of flames. One hour later, despite the efforts of three departments all that remained of the building was the four walls that were expected to topple each minute.

Chief ELY SEYMOUR of the Plattsburg department summoned the departments at Plattsburg barracks and Morrisonville. With the six

streams of water played on the doomed building the firemen were able to prevent the blaze from spreading to the nearby residences.
Teacher Saves Six.

PROF. LYNDON R. STREET, *director of music, was giving music lessons to six youths,* LYON PETERSON, HAROLD JERRY, JR., JACK AGNEW, PAUL AGNEW AND MYRON DEVENBERG, *when he observed smoke escaping beneath the door leading out into the long corridor that extends from the north to the south wings of the school. Opening this he found the corridor was a mass of flames and that the nearest exit was cut off. Rushing back into the room on the first floor in the south wing Professor* STREET *threw up the window and lowered the youths to the ground. All escaped injuries with the exception of* JACK AGNEW *who was injured when he dropped to the ground, a distance of about 20 feet. He was taken to Champlain Valley Hospital where he was treated by* DR. LYMAN BARTON. *Although the extent of his injuries could not be learned they are not thought to be serious.*

The building which was constructed in 1892 accommodated 600 students, 100 of which were grade school pupils. The school was noted for its commercial course, which was established by DR. GEORGE K. HAWKINS, *present head of the school.*

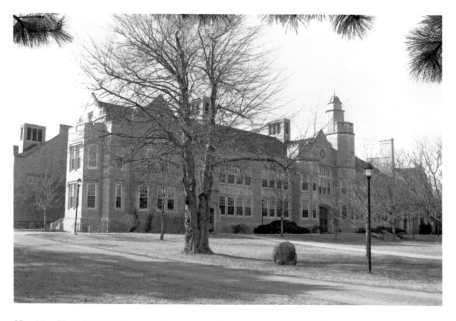

Hawkins Hall, SUNY Plattsburgh campus. *Photo courtesy of SUNY Plattsburgh.*

Plan New School.

According to the valuation set down in the legislative manual the value of the property was set at $235,000. The City of Plattsburg carried an insurance policy for $87,500 on the building.

An appropriation for a new building is pending in the State Department at Albany. No definite arrangements have yet been made for taking care of the students but it is believed that the city will be asked to furnish several public halls in which to continue sessions until such time as a better solution to the problem is found.

Parnaby, the same janitor who discovered Blanchard the day he succumbed to illuminating gas, was on duty and was questioned by local police, but he hadn't noticed anything suspicious or even unusual. In the end, the cause of the blaze was said to be "spontaneous combustion." That makes sense; ghosts rarely leave evidence.

A new structure was built on what could be salvaged from the original, and in 1955, it was renamed after George Knight Hawkins, the school's principal from 1898 to 1933, to honor him for his tireless efforts to reconstruct the main building after the fire. And what of poor John Blanchard?

There have been modern sightings, and students and staff say they still feel his presence. Let's hope he doesn't feel the need to light a fire under them to get their attention.

Chapter Five

MYSTERY AT MACDONOUGH HALL

I find dormitory ghosts particularly creepy and opportunistic. Let's face it—they prey on young people far from home who are grappling with the important questions in life, like whether it's okay to wait until Thanksgiving break to do their laundry.

When my daughter was a student living in a dorm called Whitelaw at Vermont's Lyndon State College, she was frequently visited by a ghost that we believed was causing her to experience sleep paralysis. According to Swedish folklore, the phenomenon is caused by a supernatural creature called a "mare," from the old English word *maere*, meaning "goblin" or "incubus." This female entity visits victims during sleep, sitting on their rib cages and causing them to feel suffocated while she imprisons their minds. The word "nightmare" is derived from this word.

Science calls sleep paralysis a medical condition. It's been linked to narcolepsy, in which sufferers have frequent daytime "sleep attacks." Most cases of sleep paralysis involve a sensation of being unable to move or speak, and there is also an imagined presence of a controlling entity. The symptoms often include fear and an inability to communicate by speaking or crying out, issues similar to those described by people who have recounted being abducted by aliens.

My daughter's nightly visitations were different. Rather than some weird disruption of a sleep cycle, her ghostly visitor was very specific in its message and wanted her to listen. It returned again and again, waking her so she could be its captive audience. She realized, once she got used to the spirit's

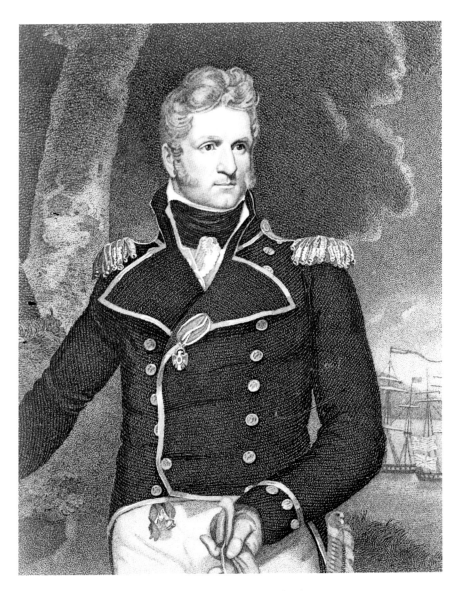

Commodore Thomas MacDonough. *Image courtesy of Wikipedia.*

modus operandi, that she could call out to her roommate, but she didn't want to wake her. Still, the last thing she needed with schoolwork and a part-time job was a chatty apparition disrupting her REM cycles. She did what she does now when a spirit who sees her as an easy psychic mark starts to get annoying. She told it to bug off.

Too bad she can't advise residents of MacDonough Hall at SUNY Plattsburgh. MacDonough Hall, an H-shaped building with coed dorms, is the third oldest building on campus. It was named in honor of Commodore Thomas MacDonough, who fought in the War of 1812, and its mysterious reputation goes back to the hall's groundbreaking in 1948. When site preparation began, workers discovered two tombstones, possibly part of a very old family burial plot. The names were feminine. They belonged to a mother and her daughter, who had died very young. The workers placed the stones near the road, away from the dig, so they could keep them out of harm's way while they figured out what to do with them. When they went to check on them the next day, they discovered both stones had vanished.

Their disappearance was never solved, but a group called the Paranormal Investigators of New England conducted an investigation of MacDonough Hall. Based on evidence they gathered, including a voice projection picked up by one of their sound recorders, they have reason to believe a female entity does make her home there. Unfortunately, the only clues to who she might be were lost long ago.

A student named Kelly lived in MacDonough Hall back in the eighties. She says the dorm was one of the scariest places she has ever been. In 1984, her sophomore year, she and a friend decided they wanted to room together, and they merged their belongings in a second-floor room in MacDonough's west wing. After they moved in, Kelly began to feel like whenever she was in MacDonough, someone was watching her. It was a looming, malevolent presence. Even walking down the building's halls was unpleasant.

Whoever the entity was, it seemed to like keeping people on edge. The fire alarm would go off each night, sometimes more than once, but there was never any fire.

One day while Kelly and her roommate were studying, they both stared as a washcloth on their towel rack was very deliberately lifted high off the bar and dropped to the floor. Later that night, in her upper bunk, Kelly tried to forget about it and fall asleep. From her roommate's bunk below, the only audible noise was the turning pages of the book she was reading. All at once, Kelly felt overwhelmed by a smothering sensation. Someone was pinning her down! She called out to her roommate. "What!" her roommate asked and then yelped, "Someone just called our names!"

Not long after that episode, Kelly moved to another building. After graduation, she and her friend kept in touch, even meeting up once each summer on Cape Cod. One night, while talking about the experience at MacDonough Hall, her friend had a confession to make. "Remember how

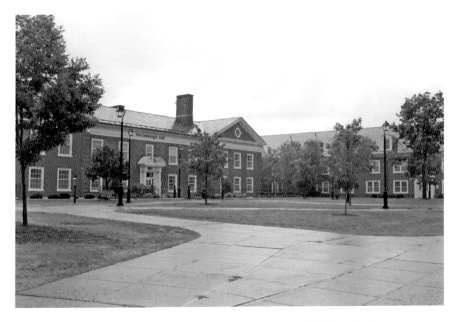

MacDonough Hall in Plattsburgh, New York. *Photo courtesy of SUNY Plattsburgh.*

I told you it said both our names?" she asked. "It didn't. I was afraid to tell you this because I knew how much it would scare you. It really only said *your* name."

A student named Camille Gotti experienced what she believed to be ghostly activity in MacDonough Hall. One night, while she and her roommates were watching television, she saw a water bottle she had placed on her desk earlier begin to rock back and forth as if moved by someone, though no one was anywhere near it. Another young woman, studying all by herself in the lounge, suddenly heard the sound of unsettling laughter and something else: the lounge piano was playing, but there was no one there. There have been reports of strange, frightening images in the building's mirrors and other reflective surfaces, tinkling sounds and missing items that turn up later in odd places.

Chapter Six

MURDER IN PLATTSBURGH

As a patron saint, John the Baptist shoulders a heavy load. He's the protector of all kinds of people and professions, from tailors to farriers, and he can come to your aid in the event of convulsions, hail storms and problems you encounter on the highway. Too bad his to-do list didn't include interceding when a Roman Catholic cemetery named in his honor was bulldozed to the ground—a rash act that, depending on who you believe, was spurred either by confusion or convenience.

St. John's Cemetery, which stood at the corner of South Platt and Peru Streets in Plattsburgh, New York, has long carried a reputation for being haunted. That is not surprising, considering transcriptions show burials that date as far back as 1820 on land that saw war throughout the eighteenth century. Still, whatever ghosts did dwell there were benign and quiet, and so was the cemetery's public face.

In the late seventies and early eighties, though, the old Catholic graveyard had fallen victim to disuse and neglect. Its regular visitors were the teenagers who would arrive on Halloween each year to vandalize the place (on one occasion tipping over a whopping sixty-nine headstones in one night).

Then, in June 1983, a tragic blunder gave spirits at St. John's a reason to feel restless. Newspaper accounts from the period tell this story: Monsignor Morris L. Dwyer, presiding pastor at St. John's Baptist Church, was heading to a retreat at Wadhams Hall in Ogdensburgh, New York. Before he left, he hired a contractor named Floyd Sears to clear one acre of land on the cemetery grounds, a section adjacent to an acre a different contractor had

cleared the year before. It was Dwyer's goal, as stated in an article in the *Plattsburgh Press-Republican*, to have Sears level a portion of the grounds so the city could take over the responsibility for mowing the area. But Sears, whether by his own design or under the instruction of an anonymous party, hired enough men and equipment to clear away about five acres of cemetery plots, including monuments. Citizens, catching wind of what was happening, arrived on the scene pained and outraged. But Sears instructed his men to continue. It wasn't until the negative public sentiment reached dangerous proportions that the monsignor was contacted, and a message delivered by Reverend Ivan Bouyea stopped the demolition. But by then, it was too late. The 150-year history of the cemetery conveyed by the sacred headstones of mothers, fathers, children, grandparents and great-grandparents was unceremoniously bulldozed over the cemetery's northern embankment and into the river.

The decision by the monsignor came at an unfortunate time. He should have been basking in good wishes, since his forty-fifth anniversary with the parish was to be celebrated that same month. But he was coming under fire from church members over the fact that no one had been notified about the work being done at the old cemetery.

On the defensive, Dwyer claimed not to know why Sears had engaged in the full-scale destruction of the cemetery, saying perhaps he should not have

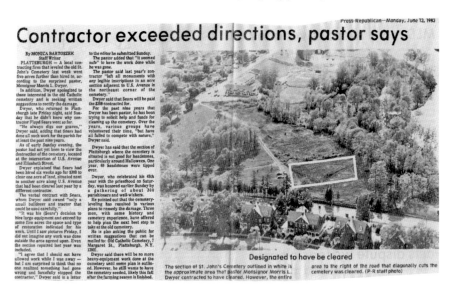

St. John's Cemetery news clipping. *Courtesy* Plattsburgh Press-Republican.

allowed the work to be done while he was away, but the big picture looks pretty damning. The City, which Monsignor Dwyer claimed was planning to take over the maintenance of the property, said it had no agreement with the church. Aldermen acknowledged the cemetery was an eyesore but added they didn't condone what had gone on there.

Sears, for his part, was unapologetic. He stated publicly that the cemetery was a tangle of roots, broken headstones and fallen trees that had gone unmaintained for decades and that the decision was a matter of dollars and cents. It certainly was for Sears. He was paid $300 for the demolition.

In 1989, volunteers began restoration efforts. A letter from a Wisconsin woman looking for an ancestor who had served in the Civil War spurred local veteran organizations, along with members of the 380th Civil Engineering Squadron from the now defunct Plattsburgh Air Force Base, to begin the time-consuming task of retrieving and replacing the markers that had been lying for six years on the banks of the Saranac River. There was both satisfaction and sadness in the task. Many stones were too damaged to save, and some were so weathered that it was difficult to read the names. Monuments that could be restored to the burial ground would never be able to be placed exactly where they were before the demolition.

A woman from Tacoma, Washington, Patricia Kulman Samuelson, was researching her family history when she discovered she had ancestors who had been well known in the Plattsburgh area. After she shared what she had learned with her cousins, Jean Dubabin and Stephen Rowles, Jean decided to make the trek back east to check out their family's origins firsthand. When she went to pay her respects at her ancestors' final resting place, she discovered physical evidence of their graves no longer existed. But there was another shock for the family: They learned one ancestor they shared, a man named Owen O'Neil, was the victim of a grisly murder. If his ghost roams the desecrated stretch of St. John's Cemetery today, it is not without good reason.

Owen O'Neil was a landowner who lived with his wife, Catherine, and their eight children on a large farm on the outskirts of Altona, New York, not far from Plattsburgh. The distinguished thirty-eight-year-old was well known and well regarded in the community. He was an honest businessman and a trustee for the local school department. On July 4, 1884, forgetting it was a legal holiday, he set out by horse and buggy for Plattsburgh. It was his plan to take care of some accounts at the National Bank and pick up some supplies that were needed at home. Arriving in town, he discovered the bank was closed, so he went about his other errands. As evening

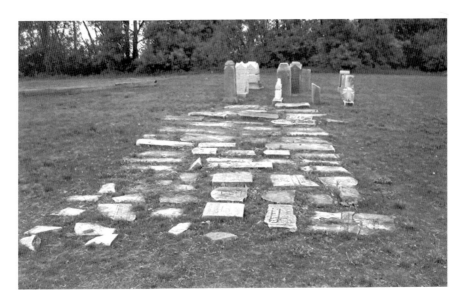

St. John headstones after the retrieval. *Photo courtesy of Patricia Kulman Samuelson.*

approached, he stopped to have a drink or two but no more. After a bit of socializing, the summer twilight found him ready to head for home. Witnesses said he got in his buggy with a man named Murry, but they only rode as far as Cornelia Street before O'Neil realized he had left a package behind and needed to double back to retrieve it. This left Murry, whoever he was, to set off on foot alone.

Reports differ from this point forward, but one thing is certain; there was no one able or willing to say they had seen Owen O'Neil alive after that. One individual reported that, later in the evening, on the road he would have followed home, there were three men in a buggy having some sort of argument. They said the vehicle was being pulled by a white-faced horse that looked just like O'Neil's. As evening turned to the wee hours of the morning, neighbors on the other side of the hill from where the buggy was last seen were awakened by the sound of a horse and wagon going past their homes at a pace that was no more than a slow walk. They also heard persistent groans that slowly faded into the distance. It was assumed some drunken, mournful soul was making his way home after an evening of too much gin and ale.

Early that morning, Owen's wife, Catherine, dressed and went out to the yard. Seeing that the horse and buggy were under the shed but finding

no sign of her husband, she went into the house. She woke her fourteen-year-old son, Lawrence, so he could help her unhitch the horse. When poor Lawrence got to the yard, he saw what his mother had not noticed until just moments before. There was his father, broken and lifeless, dangling between the wagon box and the right front wheel. He had been stuffed into place over the axle, and over the course of the slow walk home, his clothes were worn to shreds, his skin and muscle tissue eroded, his upper thigh bone and hip socket worn away. The spokes and hub of the buggy wheel were worn from the contact with his body. The marks in some of the spokes were an eighth of an inch deep. Neighbors hearing what had happened were filled with disbelief and horror, realizing the noises they had heard the night before were the sounds of Owen O'Neil being slowly ground to death.

A coroner's inquest ruled accidental injury unlikely. O'Neil had had a few drinks earlier in the day, but there was little alcohol in his system at the time of his death. It was considered impossible that he could have fallen in such a way as to end up as he was found, so entangled in the workings of his buggy. There was one more thing: a pool of blood in O'Neil's temple and two wounds, both of which indicated a blow to the head by a blunt

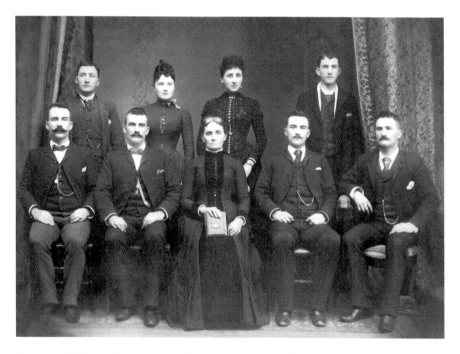

Catherine O'Neil and her children. *Photo courtesy of Patricia Kulman Samuelson.*

instrument. Inside the buggy, Owen's hat had been found with two dents that corresponded with the location of the wounds. His pocket watch was gone, his money was missing and a fresh set of wagon tracks could be seen in the mud near his house. Authorities figured someone had driven with him as far as the yard and then headed back.

No one was ever arrested for the murder of Owen O'Neil, but his relatives always suspected a man named Peter Leonard, whose home was on the route between the O'Neil farm and town. Jean Dunbabin's grandfather, John F. O'Neil, once gave Leonard a good beating after a friend pointed him out in a local bar.

A November 1890 article in the *Plattsburgh Sentinel* also mentions Leonard in connection with the murder. Leonard was acting as an attorney in a petty suit on behalf of a man named John Butler of Beekmantown against a fellow named William Loughan. In the heat of testimony, Leonard claimed to hear Loughan call him a forger and a murderer, and he accused Loughan of slander. Through testimony in the ensuing court case, it was learned that Leonard *had* been charged with altering a note at the Merchants Bank and that authorities had suspected him of foul play in the murder of Owen O'Neil but couldn't make anything stick.

In 2003, Patricia Kulman Samuelson visited his final resting place and was able to see the new stone she and her cousins had created to replace the one that was lost in June 1983. It was placed as close to the location of the original as possible. Its inscription reads:

Weep Not For Me, My Family Dear
A Murdered Man Lies Sleeping Here
But God Who Is Good And Just And True
Will Give The Murderer All His Due

If proximity is a factor, Owen's passing time at St. John's may not win him vengeance in his murderer's afterlife. Leonard isn't listed in the transcription of stones that existed before demolition. But so many generations of history were lost and all before the advent of Google, so it is hard to know for sure. I'm reminded what a luxury it is to have so much information at your fingertips. I would never have found Pat and her cousins without the Internet.

There is some good news for those curious about those interred at St. John's Cemetery. Beginning in 1933, a man named Hugh McLellan, his son, Charles Woodbury "Woody" McLellan, and his daughter-in-law, Hulda (Bredenburg) McLellan, visited various cemeteries throughout Clinton

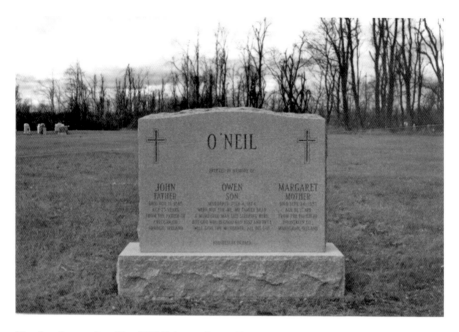

New headstone placed by O'Neil descendants. *Photo courtesy of Patricia Kulman Samuelson.*

County, where they painstakingly copied legible inscriptions from the cemetery stones. The lists they created were donated to SUNY Plattsburgh, and complete sets can be found at the Plattsburgh Public Library, the Clinton County Historian's Office in Plattsburgh and the Northern New York American-Canadian Genealogical Society in Keeseville, New York. Each town historian has a copy of his or her segment as well.

Chapter Seven

BY DUNDER!

Stand on the overlook at Red Rocks Park near the Burlington, Vermont shoreline and you will see Juniper Island. But hold on a minute—what's that funny-looking bump sticking out a little bit to the left?

That would be Rock Dunder, a mass of solid stone topped with shale that rises out of the lake just far enough to bamboozle boats that travel the bay.

Abenaki legend attributes the rock's existence to the supernatural being Ojihozo, "He Who Created Himself." Ojihozo (also spelled as Oodzehozo) was an impatient deity. Before he was fully formed, he dragged himself around on his hands, forming his tribal lands, the mountains, the rivers and streams and his last great work, Lake Champlain. It is said that he was so pleased with this creation that he climbed onto a rock in what would become Burlington Bay and turned himself to stone, so that he might forever enjoy the sight of what he had made.

An 1869 *New York Times* article revealed that during the French and Indian War, the rock was the spot where the Huron, the Iroquois and other tribes would meet to make their treaties, though one has to wonder why they would choose to do so in the presence of another tribe's revered spirit.

To many, Rock Dunder might not seem a suitable meeting place for anyone but a flock of seagulls, but there are accounts of Abenaki tribe members bringing offerings to Ojihozo into the 1930s and '40s. The spot is still considered sacred by the Abenaki today.

Over the years, many a wary captain viewing Rock Dunder from a distance has mistaken it for another ship, so it's probably no surprise that,

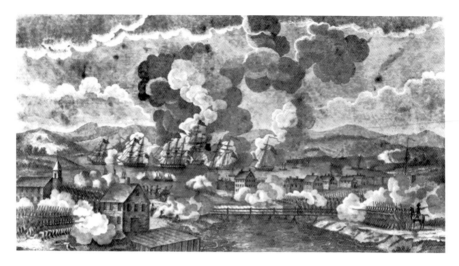

Battle of Plattsburgh. *Image courtesy of Historic Lakes.*

according to legend, parts of it were blasted away more than once during military skirmishes near Burlington's harbor. Rock Dunder owes its name to just such an incident. During the Revolutionary War, at the height of the Battle of Lake Champlain (also known as the Battle of Plattsburgh), a Dutch sea captain on a British vessel ordered his men to fire on the rock (then blanketed in a thick fog) because he thought it was the enemy. It wasn't until the fog cleared that the officer realized that his error had caused them to waste valuable time and ammunition. Frustrated and embarrassed, he called out, "It's a rock, by Dunder!" The story of his mistake and the ensuing exclamation passed by word of mouth through shipyards and taverns, and the name stuck.

Vermont Pub and Brewery, which sits at the corner of Burlington, Vermont's College and St. Paul Streets, liked the name well enough to name an ale after it. Sadly, the flavor has been retired, but many other fine craft beers await you at this popular restaurant and watering hole. You'll find a dazzling array of porters, pales and stouts. Ghost-loving patrons will be excited to note that Vermont Pub and Brewery also boasts spirits of a different kind.

Head brewer Steve Miller says his first ghostly encounter at Vermont Pub and Brewery happened a little over a decade ago, when he was still fairly new to the place. He was working by himself in the basement brewery when he saw someone in the vicinity of the drain area in the middle of the floor. "It was a guy, tall, about six feet, with dark hair and a beard," Steve told me.

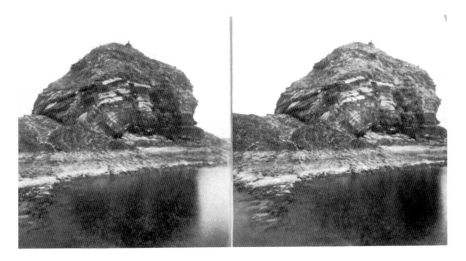

Stereoscopic view of Rock Dunder. *Image courtesy of Wikipedia.*

"He didn't seem unfriendly, [but he was] just watching, curious, and then he vanished." Steve recalled that, several years later, he felt someone brush up against him while he was working next to the row of big fermenting machines. "I turned around. The two feet of space between me and the wall was empty. There was no one there."

Another longtime Pub employee, kitchen manager Mike Trepanier, also sighted something strange in the basement. He was headed to the men's room on the other side of the wall from the brewing room when he saw someone he didn't recognize entering the restaurant's dry storage area, a locked space employees call "the cage." "I'm thinking, whoever is headed in there, I've got him now! But I got in there and there was nobody there. There's no exit. He was just...gone." Ghostly tales aren't really Mike's thing ("If you can't explain it to me scientifically, it didn't happen."), but he has had more than one encounter with whatever is haunting Vermont Pub and Brewery:

One morning I was in really early, cooking. In the kitchen, we've got a shelf up near the ceiling. It's holding some good-sized pots, nested, some as big as sixty quarts. But it's built so that it tips back, so they won't fall. I'm standing there, all by myself, and all of a sudden a stack of pots comes flying off the shelf and lands in the middle of the floor. I remembered someone had told me they thought the ghost was named Randy, someone they heard had died in the building. I remember I yelled, "Randy! Knock it

"The cage" at Vermont Pub and Brewery. *Photo by Roger Lewis.*

off!" Then, I did get out of there, fast. I waited outside for somebody else to show up for work before I went back in.

Customers aren't immune to the stranger that haunts Vermont Pub and Brewery. After using the restrooms in the basement level, some have come back upstairs with tales of an apparition that steps up to join them while they relieve themselves (or sometimes stands back, simply watching).

There is a joke that, when it comes to beer, you don't buy it, you only rent it. Sounds like when you drink the beers at Vermont Pub and Brewery, you might get more than you paid for.

A SPOOKY SIDE STORY

Vermont Pub and Brewery owner Steve Polewacyk was quick to tell me he is not "a ghost guy." And that's okay. I have been doing this long enough to have

met my share of nonbelievers. The funny thing about these nonbelievers is that quite a few of them have their own ghost stories to tell. After pointing me in the direction of staff members who had odd experiences in his building's basement and kitchen, Steve told me a story of his own:

> *I had just moved into a new house. I was really busy, so for a while, there were boxes all over the place. After a while, I began to notice that the boxes were moving. At first, it was just a little, [very] subtle, but more and more, I'd come home and there would be boxes in places I knew they weren't when I left. Then, one night, I was sitting by myself at the kitchen table, and there was this giant thump up against the wall, really loud, you know? Like someone had heaved a medicine ball at the building. But I went outside, and there was no one around. It happened other times, too. Every time, nobody there. So, one night, I had some friends over, and we're all sitting around talking and, bam! I asked, "Did you hear that?" Everyone did. Things kept happening for a while after that. Finally, I just got tired of it. One night I got home and said to whatever it was, "Listen. Just knock it off. There's plenty of beer here. You leave me alone, I'll leave you alone." After that, everything was fine.*

Vermont Pub and Brewery, the third-oldest brewpub on the East Coast, is at 144 College Street in Burlington.

Standout offerings are the brewery's fish and chips and the Vermont country meatloaf with onion gravy.

For beers, try Handsome Mick's Irish Stout, Bombay Grab IPA or Dogbite Bitter.

Vermont, Pub and Brewery, Burlington, Vermont. *Photo by Roger Lewis.*

Chapter Eight

SIT RIGHT BACK
AND YOU'LL HEAR A TALE

When I was a kid, the word "island" always made me think "Gilligan." It conjured up images of hammocks, headhunters and radios that ran on batteries made of coconuts. Lake Champlain's islands may not feature Pussycat Swallowtails, musical versions of *Hamlet* or pigtailed sweethearts with amnesia, but a few of them are pretty intriguing. The following are some stories we shouldn't overlook.

STAVE ISLAND

Stave Island is to the north of Malletts Bay, close to the shores of South Hero, Vermont. A long-told legend has it that a laborer was sitting in the shade one day, about to unwrap his lunch, when he noticed a funny carving on a nearby tree. Upon closer inspection, he realized it was a crude rendering of a human hand with a pointing index finger. Looking around to see who might be watching, he climbed the tree to have a look around. Sighting from the direction the carving indicated, he saw a large, flat rock in a nearby meadow. He made his way down to the ground and strode quickly to the rock. Checking once again to make sure no one was the wiser, he attempted to lift it but failed. "Blast!" he thought, agitated. But then, he reconsidered. He was probably getting carried away with himself. Who knew how long the carving had been there or what it meant. He resolved to forget about it and went back to his work.

That night, though, thoughts of the carving and the rock made him toss and turn. It was possible the hand meant nothing, but could it also be true that the rock concealed buried treasure he had heard the old-timers whisper about?

The next day, he called upon a friend and asked him to accompany him out to the island. When they got there, they quietly pulled their boat onto the sand and made their way to the clearing and the big rock. As they bent to try to move it, a dark shadow fell across them. It was the island's caretaker, who told them if they were seeking treasure, they should know anything they found was considered the property of the island's owner. Finding their adventure more than they had bargained for, the two men left.

But a week later, there was a knock at the workman's door. It was the caretaker, who had come to say the laborer and his friend could have a go at the boulder, but on one condition: They must share with him any booty they might find. The man agreed. Unfortunately, he became ill soon after the caretaker's visit and couldn't travel to the island. Finally, on the eve of the day they had planned to go out to the island to move the rock, there was a terrible fire that ravaged the forestland and removed all evidence of the hand, the tree and the location of the flat rock. Folks say the treasure has never been found.

CRAB ISLAND

Say a prayer for the spirits of Crab Island. This historic site, originally named St. Michael by explorer Samuel de Champlain, is about a mile from the shores of New York State. It played a key role in the Battle of Plattsburgh, which ended the final invasion of the northern states during the War of 1812. Around September 1814, a makeshift military hospital fashioned out of log structures and tents made of canvas and boards was built on the island to care for the injured, who numbered over 700. After the battle, Crab Island became a repository for the bodies of soldiers for both British and American fleets. The bodies of the officers killed in the battle all received military burials in Plattsburgh's Riverside Cemetery, but 150 enlisted men, some of whom died on the island and some of whom were washed ashore, were buried shoulder to shoulder in three long trenches somewhere south of the hospital (reportedly, the only time in history that British and American soldiers were buried together in this manner). The actual site of their graves

was never marked. The island was eventually made a historic site, and a caretaker and his family did their best to tame the grounds of what was renamed MacDonough National Military Park. It was a daunting task since the island was (and still is) covered with what has been described as a "plague" of poison ivy.

The caretaker, Sergeant Thomas P. Connolly, and his family endured the rustic (outhouse, no running water, a mile of lake between them and civilization) circumstances on Crab Island for seven years. They left in 1915, but no one knows why. The island went untended for decades.

Then, in 1986, there was a crazy turn of events. While the State of New York made plans to take possession of the island, which was up for sale, the island was bought out from under it by a New Jersey millionaire named Roger Jakubowski. Jakubowski, who had made a fortune selling hot dogs on the boardwalk in Atlantic City, was on a roll, buying up prominent properties in the Adirondack Park just because he could.

After outbidding New York for Crab Island, he laughed and said, "Where else can you buy a historic site as important as Arlington National Cemetery for 190 Gs?"

Crab Island. *Photo courtesy of Historic Lakes.*

Locals were in an uproar that the historic site had been bought out from under them. Papers were calling the standoff between Jakubowski, who wouldn't divulge his plans for the land, and locals "The Second Battle of Plattsburgh Bay."

At a public hearing on the island's future, held July 29, 1987, all but two people in a crowd of more than one hundred said that they felt the island should be publicly owned. The state began the process of claiming the island under eminent domain and took possession in January 1988. Jakubowski, who had vowed to be a good caretaker, said he would fight having to relinquish ownership, but in the end, he did not contest the property changing hands.

Officials will pardon me (I hope) when I say Crab Island still does not get the attention or respect it deserves. It's true that, in the past, the United States and the State of New York spent thousands of dollars to procure and preserve the island, but today, there is not an assigned caretaker, nor does the government regularly maintain the property. A great debt of gratitude is owed to Roger Harwood, a retired teacher from Plattsburgh, who volunteers his time picking up trash and tending the grounds.

If you plan to visit Crab Island, you should know that, while some of the paths have been restored, it is a nearly unrivaled breeding ground for poison ivy. Other flora and fauna on the island are protected, so please take only pictures. In fact, you would do well to give the entire island the respect you would a grave site, since the exact location of the 150 men buried there, or anyone else who may have perished on the island, is unknown. Artifact hunters should leave their metal-detecting devices at home. Those and digging are strictly prohibited.

For more on Crab Island's history and significance to the Lake Champlain area, read James Millard's *The Secrets of Crab Island*, available at historiclakes.org.

GARDEN ISLAND

In 1758, while waiting for the arrival of the Black Watch at Fort Ticonderoga, the Marquis de Montcalm was a little distracted. As he ordered his men to surround Fort Ticonderoga with a tangle of logs and sharpened stakes to forestall the attack, the payroll for the men who were serving under him during this critical battle of the Seven Years' War was already wildly overdue. The last word from Montreal was that it was on its way in an iron chest on

a bateau—a long, light, flat-bottomed boat—that had started its trip south two weeks earlier. The marquis had received no word since. While worrying that the mighty British forces who were on their way would overtake his fort and claim victory, Montcalm received a message that threatened to cloud his thinking. The clumsy bateau had capsized close by, near a place then called "Little Garden Island." Now, the chest with the payroll was sitting on the bottom of Lake Champlain. The battle began, and a fierce one it was, with Montcalm's army defeating the redcoats. The celebration was short-lived, however; the chest was never found. For more than two centuries, treasure hunters have plotted to bring the gold up from the lake near Garden Island. So far, no luck.

VALCOUR ISLAND AND THE BLUFF POINT LIGHTHOUSE

Campers on Valcour Island tend to rise in a crabby mood. Why? They can't get any sleep. A creepy sensation of being watched in the night, haunting whispers, heavy breathing and the mournful sound of singing are just some of the phenomena noted by visitors.

Blood was spilled at Valcour Island when General Benedict Arnold led an American fleet of fifteen vessels there on October 11, 1776. The battle raged more than five hours. One ship, the *Royal Savage*, ran aground and was bombarded mercilessly. It was later abandoned and then captured and burned by the British. There were heavy casualties on both sides. Is the mournful singing heard in the wee hours by visitors to Valcour coming from the ghosts of battle or spirits of another kind? Perhaps a more free-spirited ghost haunts the island. During the 1870s, a society called the Dawn Valcour Agricultural and Horticultural Association built a commune there. Known for promoting "free love," the group was looked upon with suspicion by mainland locals. It is hard to imagine that they could do much damage to society, though. Just three people spent one lone, harsh winter on Valcour, leaving in 1874.

After the society abandoned Valcour Island, Congress approved purchase of the land and erected Bluff Point Lighthouse. Beginning July 14, 1876, the lighthouse was maintained by Major William Herwerth and his wife, Mary, who moved to the island with their children. Major Herwerth, a Civil War veteran, had sustained an injury in the war that would contribute to his death in 1881 at the age of fifty-five. Maybe it's his ghost that roams the

island, restless with unfinished business. Or maybe it's the echo of his wife, Mary, who took over for him after he died and faithfully kept the place going until her death in 1902. It's not hard to imagine her spirit singing a lonely song while she continues her husband's duties long after his death.

In 1930, a freestanding tower with an automatic light made the lighthouse obsolete. In 1954, Dr. Adolph Raboff, a dentist from Massachusetts, bought the property, using the lighthouse as a summer home. In the mid-1980s, he offered his land to the State of New York, which controlled the rest of Valcour Island. It was the state's short-sighted plan to tear down the lighthouse, but the doctor would only give it the property if it agreed the lighthouse would be preserved. The lighthouse, owned by the state since, has been restored and is maintained under the guardianship of the Clinton County Historical Association. It has developed several displays that aid in interpreting the site, and it controls the schedule for lighthouse keepers and visitors.

On November 16, 2004, the light was transferred back to the lighthouse lantern room, eliminating the need for the modern light tower. A public ceremony celebrating the relighting was held on June 12, 2005. Bluff Point Lighthouse is the only lighthouse on Lake Champlain listed on the National Register of Historic Places.

If you would like to see Valcour Island and the Bluff Point Light for yourself, check out the visitors' schedule at clintoncountyhistorical.org or call 518-561-0340 for information. Please be aware that, while the lighthouse will be open, the historical society does not provide transportation. For a few different ways to get there, check out the list below.

GETTING THERE:
From Peru Dock: Take the state launch at Valcour Island from U.S. 9

From Kayak Shack: Take U.S. 9 from Plattsburgh, NY

From Plattsburgh Boat Basin: Take the launch, which is located at 5 Dock Street, Plattsburgh, NY

Chapter Nine

SECRETS OF A SWASHBUCKLER

Not long ago, I had a little bump on my eyelid. It started as a flat, shiny spot but grew into a hard little nodule that made it difficult to apply the spooky eyeliner I wear on my haunted tours. A doctor advised I have it biopsied and referred me to a surgeon in the area. When the day and time of my appointment arrived, the procedure was fast and practically painless. Still, I was disappointed. Why? Because I left the office with only a little dab of ointment on my eyelid. I had hoped that I would be going home sporting an eye patch.

Pirate stories, pirate songs, pirate couture (who doesn't appreciate a nice bustier?). I love pirates. So imagine my delight when I heard whispers of buried pirate treasure at Mallett's Bay in Colchester, Vermont, just up the lake shore from my Burlington home. Mallett (pronounced "Ma-lay"), the character the bay is named after, was said to be a swashbuckling captain whose first name could be one of several names. But whether you call him Captain Stephen Mallett, Captain Pierre Mallett or Captain Jean-Pierre Mallett, it pays to take care when visiting his old haunt. If you don't, you might lose your head.

No one knows for sure where Mallett got his reputation for superior skullduggery. Some say that he fled France while serving under Napoleon, taking with him regimental funds intended for delivery to Louisiana. Others claim his "treasure" came from pillaging any ship he set his spyglass on as he made his way to and through the colonies. However he obtained his wealth, he followed Lake Champlain to Vermont and found a small place that was out of the way where he could lay low.

Some written accounts describe him as a recluse, a former seafarer tired of pillaging and preferring a peaceful country life. Other accounts say he also owned a tavern on the shore, where he gave sanctuary to travelers, for a price, while keeping his hand in the pirate game. Opinions diverge on the captain's life once he tucked himself away into his Colchester abode, a log building on the bay shore that Ira Allen said had "the appearance of great antiquity." One thing people seem to agree upon is that the ex-buccaneer was a man with a secret: a pirate's chest full of doubloons he wanted all for himself.

Legend has it that, late one cloudless night, a stranger at Mallett's tavern followed him to the place where he had stashed his loot. Discovering the intruder, Mallett swiftly took off his head with a cutlass. But where was Mallett to dispose of the evidence? And how would he keep future prying eyes from discovering his booty? Simple: He would bury the treasure with the body.

Years later, everyone is still trying to figure out where Mallett stashed the corpse and the cash. We may never know. Boaters and hikers visiting the area have claimed to see a spirit in eighteenth-century dress not just on Mallett's Bay but also across from the bay on the shores of Coates Island. Even though we can't be certain where the gold and the victim were hidden, it would probably pay to take care at either location, if only to avoid being frightened to death by a headless apparition or sliced to ribbons by Mallett's ghost.

Chapter Ten

THE BLACK SNAKE AND THE FLY

One night, in the middle of researching for this book, I took a break and watched some mindless television. It was a popular talent competition, and during that episode, a winner would be crowned. As the MC revealed how many people were in the auditorium (seven thousand!), my mind raced to the story of *The Black Snake* Affair and how ten thousand people gathered to witness a public hanging in Burlington, Vermont, way back in 1808, the accused having been charged with one of the most notorious crimes in Lake Champlain maritime history.

It all began on August 3, 1808. A regiment of twelve men was aboard the revenue cutter *The Fly*. Led by Lieutenant Daniel Farrington of Brandon, Vermont, the men on *The Fly* were sworn to uphold the Embargo Act of 1807, a giant tit-for-tat enacted by Thomas Jefferson that was meant to stop *another* embargo between England and France. Farrington was following a path from Lake Champlain to the mouth of the Winooski River, hot on the trail of a single-masted boat called *The Black Snake*, which was on its way back from a run to Canada. Originally built to run as a ferry between Charlotte, Vermont, and Essex, New York, the *Snake*, purchased by John and Ezekiel Taylor, had become one of the most infamous smuggling vessels on Lake Champlain. When commerce on the lake became dangerous, the Taylors hired Truman Mudgett, one of the more notorious navigators in the region, to act as captain. His crew was made up of ruthless men with reputations for being rough, exceedingly crude and dangerously volatile. These men were armed with a variety of weapons designed to keep the revenue boats or

anyone else at bay that threatened the security of their transport. In addition to the boat's large gun (or blunderbuss), each of the seven men had at his disposal a gun, a spike-pole, several clubs that were at least three feet in length and a basket of stones, each one larger than a man's fist.

The ship got its name from its hull, which was smeared with black tar to keep it from being spotted at night. The *Snake* was one of many boats engaged in smuggling potash, a substance that was useful in the manufacturing of glass and soap. On this occasion, a well-known merchant and smuggler named Dr. John Stoddard of St. Albans had hired the *Snake* to transport ashes from St. Albans Bay into Canada.

It was mid-morning that August day, and as was their custom, Mudgett and his men were hiding in a stream, waiting out daylight. The crew was off the boat when the beached vessel was spotted by Farrington and his men, who pulled up alongside it.

Despite Mudgett's stream of expletives once he realized what was happening, Farrington's men began boarding *The Black Snake*. As the authorities moved the two boats down the river, the smugglers pursued, screaming and firing into the boats. Neighboring militia joined the skirmish, and in the end, Farrington and two of his men were dead, along with a farmer named Jonathan Ormsby, who had come to talk to the officers.

Until then, most people thought the embargo pointless. Many turned their backs on the smuggling trade, possibly because it would have been hard to go far without encountering someone they knew who was making and selling potash. It was well known that in the winter months, hundreds of sleighs carrying contraband traveled from Vermont to Canada every day. But smugglers killing Vermont soldiers was a different matter. After the incident of *The Black Snake* and *The Fly*, the sentiment against smuggling and the accused was incendiary. Local papers called out for justice for the victims. A *Bennington World* article carried the message, "The best blood of your country has crimsoned the Intervales of Burlington! Treason stalks in open daylight! The blood of Ormsby calls for vengeance!"

All of the smugglers were captured. Some accounts say a few were put in stocks in the town square and pilloried. Four were charged with manslaughter and were convicted at a trial presided by Vermont chief justice Royall Tyler. One of the jurors at the trial was Ethan Allen Jr., son of the Revolutionary War hero. Allen ended up being dismissed from jury duty after his unpopular statement that the men weren't guilty of any crime and should be set free.

In the end, three of the accused received pardons. Only one, Cyrus B. Dean, was sentenced to be hanged for the murders of Ormsby and Asa March, a federalized Vermont militiaman from Rutland.

Dean, a young man of twenty-eight, didn't settle well into his role as fall guy. Newly married and the father of a small child, he had likely been drunk as a skunk when the incident occurred, since the returning cargo on *The Black Snake* included a couple of gallons of rum for the men. His attitude throughout the trial was nothing short of defiant. An escape attempt on his part caused the jailer to bring in extra materials to fortify the hoosegow and extra guards to watch him until his execution. On November 11, ten thousand citizens of Vermont, many of whom were already annoyed at the stay of execution that had occurred two weeks before, packed the few streets and tiny paths of Burlington.

It looked like Dean was finally going to meet his maker. He was taken to the courthouse at noon, where a solemn service was conducted by Reverend Truman Baldwin of Colchester. After that, Dean was taken to the newly constructed gallows, west of the old burial ground at Elmwood Avenue. There was hardly room to stand, let alone sit, as the giant throng waited for his repentance.

But they were disappointed. With the noose around his neck, Cyrus B. Dean denied his crime, spat on his coffin and pulled his hat over his eyes to await his fate. He swung at three o'clock that afternoon. It was the first and last public hanging of its magnitude in the city.

Vermont musician and folk singer Pete Sutherland wrote a great song about *The Black Snake* Affair, and he's allowing me to share the lyrics with you. The song is available at epactmusic.com.

The Black Snake *and* The Fly

A storm of war is brewin', oh see the lightning flash
Tho the woolen mills of England, they still call out for ash
In Tom Jefferson's embargo, the king of England's blind
For he cannot tell Canadian ash from our Green Mountain kind

Chorus:
And its ashes, potashes, with ashes laden down
The wily boat The Black Snake *for Montreal is bound*
So pass the word downriver from town to mountain town,
For a smuggler's grimy dollar, all the forest will come down!

Now hear this, Dr. Stoddard, your hand you soon must fold
There's a Fly *within my Customs House, a twelve-oar cutter bold*
Along the broad lake highway, this Fly *will soon take wing*
And Mudgett and his smuggler boys will feel the deadly sting
Oh tell me, Dr. Penniman, why do you raise alarm?
For tho we heed no Customs House, we mean your men no harm
Your soldiers cruise the broad lake, to stop our trade they try
But were they not born Green Mountain boys the same as you or I?
(chorus)

That long hot first of August, in the year Eighteen-oh-eight
With a jug of rum in a sheltered bay The Black Snake's *men did wait*
At nightfall to set sail again, the eastern shore to gain
Then up the Onion River, there Joy's landing they'd attain
And it was half a day behind her rowed hard the cutter Fly
On old North hero's wooded shore a handkerchief she spied
"Take care, Lieutenant Farrington where the river weaves and winds,
Follow the trail of onions and The Black Snake *there you'll find"*
(chorus)

"Lieutenant," cried the helmsman, "I see her 'round the bend
This snake be ripe for taming, her evil's at an end."
So Farrington, he jumped aboard—from the beach there came a yell:
"Now the man who lays a hand on her, I'll blow his brains to hell!
Come on my boys—parade yourselves—you're cowards to a man!
The Black Snake *she is boarded and it's we must make a stand!"*
"Your blood upon this river!" it was then the smuggler's cry
And the battle soon was joined between The Black Snake *and* The Fly
(chorus)

Now across the wide Winooski, the muskets loudly sang—
And for murdering three customs men, one smuggler has to hang
One smuggler he'll be hanged and the rest to prison gone
Tho they're sure to gain their pardon with this war a-comin' on
So raise your glass to smugglers, for they help small towns survive
And now the lake's alive with snakes—the potash business thrives
Of the reputations ruined, not one can be regained
But who with a boat and a bottle of rum might not yet do the same?
(chorus)

Chapter Eleven

BACK INN TIME

Anyone who watches ghost investigation shows on cable lives for those moments that make the hair stand up on the back of your neck, moments when someone onscreen gets brushed up against, pushed or spooked by a noise that can't be explained. From your couch (and with your heart in your throat), ghost hunting seems thrilling and dramatic, and it is... sometimes. It just doesn't happen quite the way it does on your TV.

Real-time ghost investigations are a lot quieter and sometimes downright boring. Ask Matt Borden, head investigator with Vermont Spirits Detective Agency, the "Private Eye for Those Who've Died." He'll tell you they can also be sweltering, itchy or, as I discovered when we spent the night in a Vermont castle in December, numbingly cold. I've been lucky to go on several ghost investigations with Matt and his team. I've learned that a night in a haunted house, empty university building or castle can leave you so excited that you don't think you will ever sleep again, or it can leave you crabby with a bad case of popsicle toes and desperate for a cup of hot coffee, a fresh doughnut and a soft bed, in that order.

Matt and his team have seen all kinds of haunts, from the stately Follett House in Burlington, Vermont, to the Rolling Hills Asylum in New York. They are seasoned ghost investigators whose secrets to success include lots of patience and a sense of humor.

Matt was born in the mid-fifties in the town of St. Johnsbury, Vermont. At the age of four, he moved with his parents to Anna Maria Island in Florida.

His first encounter with the supernatural happened there, over fifty years ago, but he remembers it like it was yesterday.

They lived in a wood-on-cement-slab structure known then through parts of the South as a "cracker house." Matt would lie awake in the dark, dreading the wind's creaks and moans through the building's paper-thin walls. His fear was fueled by more than a child's imagination. "One night," Matt said, "I saw a woman wearing what looked like an old-fashioned white nightgown and a bonnet. She was carrying a lantern. I stared as she floated through the kitchen door and across the floor to my parents' room. It was super creepy."

Matt spent many nights on Anna Maria Island lying in bed, too terrified to move or go to sleep. His fear of the dark stayed with him into adulthood. Things changed, though, when, through a stroke of luck (or fate), Matt found himself sitting across from television celebrity Meredith Vieira on the popular show *Who Wants to Be a Millionaire*. He did pretty well, guessing enough questions correctly to win the $25,000 prize. When Vieira asked what he planned to do with the money, he said he figured he'd start a ghost investigation business, and Vermont Spirits Detective Agency was born.

"I carried my fear of the dark with me for a long time." Matt grinned. "But ghost hunting has helped me overcome it. Now, I sit in the dark *hoping* to be frightened."

Matt is the agency's optimist. He said it is because he can hear the spirits during an investigation when others can't, and he loves it when the evidence backs him up.

"I can't always tell what they are saying, but I do hear them," he said. "Gloria says I attract them. I'm a ghost magnet."

Gloria DeSousa is Borden's partner in the agency and in life. An attractive, dark-eyed woman of Portuguese descent, she was raised by immigrant parents in the Ironbound neighborhood of Newark, New Jersey. Describing herself as coming from "hardy peasant stock," she grew up in a family that believed a person could really cast spells on people. (The missing garment from her cousin's clothesline surely *must* be the reason the cousin could not bear children. Someone must have taken the item to use it against her!)

A dog walker by day and a library supervisor at night, Gloria's career history is as fascinating as her hobby. She has a BS in preveterinary medicine (how many ghost investigators do you know who can milk a cow?) and was one of the first women to repair appliances for Sears and Roebuck. She also

has an AAS in mechanical engineering technology and worked eleven years enforcing codes as an air pollution inspector.

Gloria described herself as "a curious sort" and said that she started her foray into the supernatural the way most kids did in the seventies, with a Ouija board:

> *After only one go at it, the board spilled the beans as to who I had a crush on, my deepest secret! I truly felt something pull on it, and it wasn't my friend. Many years later, I felt that pull again during a five-day dowsing course. I could not get my rod to do anything until my teacher placed his hands on it. For the next few days, that rod felt like it was going to shoot up out of my hands anytime I crossed over a target, and I had to hold on tight. It furthered strengthened my respect for the unknown.*

Even so, Gloria is continually "flabbergasted" by Matt's ability to attract the unexplainable, and he calls her the biggest skeptic in the group. She admits her approach to ghost hunting is fairly matter-of-fact, since the investigations are often quiet and sometimes boring.

"I wouldn't call ghost hunting 'fun,'" she said. "It's interesting."

Interesting, too, is that DeSousa, a self-described insomniac, is finally able to fall fast asleep in the haunted buildings she investigates.

Matt and Gloria normally conduct investigations with their team, but on November 7, 2008, without telling anyone who they were, they checked into a place called the Back Inn Time—a bed-and-breakfast in the heart of St.

The Back Inn Time, St. Albans, Vermont. *Photo by Pauline Cray.*

Albans, Vermont, a short distance from Lake Champlain. The Back Inn Time, a restored Victorian built in 1858 by a prominent local merchant named Victor Atwood (once a trustee for Vermont's notorious reform school, the Week's School), has a reputation for resident ghosts. In fact, the spirits are featured on the inn's website. For people who live for paranormal adventures, the place seemed pretty promising.

Atwood and his wife, Charlotte Barlow Atwood, lived for a while in the gracious home with their sons, Charles Henry Atwood, who was born in 1842, and their younger son, Norman Barlow Atwood, who went by Barlow. While records show Charles graduated from Norwich, took over his father's hardware business and waited to marry until the age of forty, there is no such paper trail for Barlow, who died at the age of thirty-one. Something in my tour guide's intuition tells me Barlow is still living at the Back Inn Time. Could he be the male spirit who lurks in the downstairs parlor?

Then there is Lora, the lovely wife of Sidney Weaver, a past owner of the home. She died at the Back Inn Time when she was barely thirty years old. Another ghost, a male apparition, has been seen on the stairs. The home is said to have other secrets as well. There has been talk of a mentally challenged person having been locked in a windowless room at the inn, and a visiting medium claimed the place was connected to child slavery. (I have to wonder if she was picking up Atwood's reform school history, as many of the boys who were kept at the reform school were sent out into the community and into the veritable servitude of others to pay the school for their keep.)

After they arrived at the Back Inn Time, Matt and Gloria began an innocent conversation with the owner, Pauline, and another guest who had been at the inn for about a week. The guest told them about an amazing paranormal experience she had at the inn just a few nights before. She described not one but *two* vaporous apparitions, a host of unsettling sounds and more. Pauline chimed in, regaling them with other strange stories guests had shared during her time at the inn. When the subject of careers entered their small talk, Matt and Gloria saw no reason not to let the cat out of the bag. They told Pauline they were paranormal investigators.

Later that night, when they went up to bed, Gloria was awakened by a strange noise. From the safety of the covers, she could hear the sound of footsteps and, more peculiar, the scraping sounds of furniture being moved in the room next door. Matt's camcorder, which was left on the whole night, later confirmed the noises. It would not have been so weird if the room

Inside the Back Inn Time. *Photo by Pauline Cray.*

next door had not been a bathroom, its only furnishings of the standard, nonmoving porcelain variety.

They decided to visit again. On November 14, 2008, they came back to the Back Inn Time, this time with their gear. There were more unexplained footsteps and more unidentifiable sounds, but there was another sound this time, one that was easy to recognize. It was the sound of a man weeping. The team captured it on a recording device in a room they later learned had been the site of a suicide.

Pauline and her son, Travis, were intrigued by the evidence and offered to let Matt and Gloria return while the inn was closed, giving them the run of the entire place. They felt a little like kids in a candy store. On Friday, January 23, 2009, Matt and Gloria, along with investigators Bryan Hallett, Megan Laliberte and Mike Efendiev, conducted a full-scale investigation of the inn. Gloria and Matt got there first, setting up the infrared cameras. Bryan arrived next, and they broke for dinner. Going back to the inn, Gloria and Matt set about the first order of business, seeing if they could debunk a piece of evidence they had gathered on their last visit. (Debunking is valuable because eliminating bad data keeps you from taking a wrong turn in your investigation.)

When Gloria and Matt finally went inside, they found Bryan on the stairs. He thought he had seen a flash of movement and was asking whoever it was to please introduce itself. Nobody answered, and a digital recorder was placed on the staircase. At around 3:00 a.m., the recorder picked up a strange, alien-sounding voice. Mike ran the recording through their Audacity noise removal filter to get a better idea what the words were, but the team couldn't agree on what the voice said. (Some in the group thought it sounded like, "You're all gonna die.") Whatever the message, it was the voice itself that caused them alarm. It was loud, almost electronic and eerie, and no one had heard it with his or her own ears when it occurred. There were more auditory tricks that night, including one occasion when Bryan and another investigator, Megan, were speaking alone with Matt. They both heard someone breathing heavily behind Matt. When they mentioned it, Matt said he hadn't heard a thing.

At one point during the evening, Matt was walking down the Back Inn Time's staircase to go down the hallway to the team's "control room" when he froze. Someone had been walking with him on the last four steps. He actually *heard* the footsteps. Another investigator, Mike, already in the control room, froze as well. As he was watching Matt come down the stairs, he heard the sound of those extra steps, too, but only saw Matt and nobody else. Matt went back to the staircase. Over and over, he and Mike tried to duplicate the sound, but while the old stairs were creaky, one set of footsteps could not be made to sound like two.

At around 4:40 a.m., Matt headed to the room he was sharing with Gloria. As he lay in bed just a short time later, he heard a momentary shuffling sound that seemed to be coming from inside their room. Then, there were footsteps outside their door, as though someone was pacing on the landing between their room and the one Bryan and Megan were sharing. But it couldn't be Bryan and Megan; they would have heard them open their door. And it wasn't Mike, who was fast asleep downstairs. The sounds were troubling because while they definitely were footsteps, and they were much lighter than they would have been if they were human. Matt waited to see what would happen. Suddenly, Gloria turned to him and whispered, "Do you hear that?" Matt nodded silently. In the soft light coming from the street, they stared at the door, expecting it to open. Then, as suddenly as they began, the footsteps stopped. They didn't go upstairs, and they didn't go down. They just stopped.

Matt woke at around 7:00 a.m. As he was heading out the door to go downstairs, he encountered Bryan and Megan leaving their bedroom. The

first thing they said was, "Hey—did you hear those footsteps outside our door around 5:00 a.m.!?"

They checked their video. The hallway was completely empty during the period in question.

CIVIL WAR CONNECTION

On October 19, 1864, at about three o'clock in the afternoon, a band of more than twenty Confederate soldiers swooped down from the Canadian border, catching the city of St. Albans unaware. Their leader, Officer Bennet H. Young, and two other men had checked into a local hotel nine days earlier, saying they had arrived from St. Johns, Quebec, with the intention of taking a "sporting vacation." Every day during that month, more men arrived, and by October 19, twenty-one Confederate cavalrymen had assembled. They ransacked businesses, setting fire to Victor Atwood's hardware store and the American Hotel. They held people prisoner on the village green and shot two citizens, one fatally. They stole horses, robbed three banks and made off with more than $200,000, a fortune in those days. Citizens formed a posse to go after the marauders and captured eleven men. The soldiers were turned over to Canadian authorities but later released. Only a portion of the cash was recovered. According to legend, seven small sacks are still hidden in a pine grove between St. Albans and the Canadian border. It is said they contain thousands of dollars in gold coins.

Back Inn Time is at 68 Fairfield Street. It is within walking distance of downtown St. Albans and is only a twenty-minute drive from the city of Burlington. The inn has six rooms available, including two master rooms, each with its own fireplace. For more information, call 802-527-5116.

Chapter Twelve

GHOST SHIP

I'm a person who believes in the Golden Rule, but don't test me. My husband, my kids and my best friend will tell you that it's unwise to be the one who makes me so mad that my negative energy bubbles over like water in an untended pasta pot. Don't get me wrong: I'm basically a happy person. I'm nice to small children, fuzzy animals and clueless strangers. I'm practically Snow White singing to the little bird on my outstretched hand. So please, don't do anything that would make me want to put a whammy on you. Not that I would.

Curses. Are they real? Some people think so, even in this day and age. Persons of Middle Eastern and Mediterranean descent are familiar with the phrase "giving someone the evil eye." And those with German backgrounds are plenty familiar with hexing. And it's not just a case anymore of hens that won't lay and cows that go dry. Modern-day hexing has taken revenge to a new level. A terrible rash the day of an important job interview? A car you thought was fine that won't come close to passing inspection? Coming out of the ladies' room of a fancy restaurant on your first date with a guy you have been eyeing for months and learning the back of your dress is tucked into the waistband of your underpants? Baby, you've been hexed.

And you should pity yourself should you be so foolish as to insult the Irish. (Did I mention my maiden name is O'Leary?) You're talking more curses than you can shake a stick at. Got an egg? Try a fertility curse. Bury your eggs on someone else's land and you can steal the land's fertility and the landowner's good luck. Then there is the New Year Curse. If you steal

something from someone on the first day of the New Year, then you steal that person's luck for the year as well. With Irish curses, words often speak louder than actions. What can I say? We're a colorful lot. My favorite Irish curse goes like this:

May those who love us, love us
And those who don't love us
May God turn their hearts
And, if He doesn't turn their hearts
May He turn their ankles
So we'll know them by their limping.

I think you'll agree it's much more civilized than this one:

May the curse of Mary Malone
And her nine blind, illegitimate children
Chase you so far over the hills of damnation
That the Lord himself can't find you with a telescope.

Even though I don't employ them, I appreciate an inspired curse, like the one visited upon Captain Jahaziel Sherman back in August 1819. Jahaziel Sherman captained the steamboat *Phoenix*, a boat that had gained notoriety shortly after being built as the vessel that carried President James Monroe to Plattsburgh after his visit to the city of Burlington.

As the story goes, darkness was falling, and Sherman had just docked in Burlington's harbor to pick up passengers and goods for the last leg of his journey, the port in St. Johns, Quebec, when a crew member called him aside.

There was a woman demanding to get on the ship. She was so tiny and shriveled that he thought she must be nearly one hundred. Her English was so scant that the man could not decipher what her native language was. All he could make out was that she wanted to take the trip north but did not have money to pay the fare. Sherman considered for a moment and then laughed out loud. He told the crew member the woman was being preposterous. "Take her away!" he said. "She'll not be riding my ship without a fare."

The crew member pulled the woman back as she lunged at Captain Sherman, who strode away, his mind on other, more important things. But later that night, when the ship had left Burlington and was well on its way up the lake, Sherman surveyed the deck and happened to see something

dark near the rail. At first, he thought it was a pile of oily rags, but when he nudged it with the toe of his boot, it began to scream and curse. It was the old woman he had turned away! How had she gotten on the ship?

Grabbing her by the arm, he called to a nearby deckhand to lower a lifeboat. Together, they put the woman in it, and the captain instructed the man to take her to shore. They had reached a place in the lake called Colchester Shoal. As the deckhand rowed to shore, the woman began to scream like a banshee, her English suddenly perfect. She fixed her eyes on the captain. "You shall pay!" she cried. "You shall pay, and you shall burn!" She made good on her promise.

A few weeks later, on September 4, 1819, Jahaziel Sherman was too ill to captain the steamer on its trip north. In bed with a terrible flu, he felt he *was* burning up. His twenty-one-year-old son, Richard, took the boat out on its scheduled voyage from Burlington to St. Johns. It was a crisp, clear night, and there was a full moon. The boat left Burlington at about 11:00 p.m. The rule on board was lights out after 10:00 p.m., so most of the passengers and some of the crew were already asleep when a fire broke out on the *Phoenix*. With a wind from the north feeding the flames, the fire was soon raging out of control. People were screaming and rushing toward the lifeboats. Richard Sherman leapt into action. He alone was responsible for the safety of the passengers and crew. Firing a pistol shot in the air, he worked valiantly to maintain order and to get people off the ship to safety. A lifeboat was loaded with about twenty people and cut loose, its occupants safely on their way to shore. But something happened with the second lifeboat, and it was cut loose before it was filled. Eleven people, including young Sherman, were left on the flaming ship. Sherman encouraged those who remained to jump and save themselves. Eventually, the ship was evacuated. Sherman, too, then leapt into the water and to an uncertain fate.

Back in Burlington, Captain Richard White and his brother, Lavater, lived in a small house that overlooked the lake and had a clear view of the shoals. They were up late, talking with two other captains, Dan Lyons and Gideon King. The men saw the *Phoenix* burning near the reef and rushed to their canalboats, hoping to make a run to save it, but it was no use. The *Phoenix* sank near the Colchester reef, filling the sky with smoke. Richard Sherman, who had encouraged passengers to try to stay afloat, was found unconscious in the early morning hours, floating on a wooden table leaf. A handful of people were never recovered.

Some blamed the wind for overturning a candle in the galley. Others suspected foul play by rival transportation companies. There was even

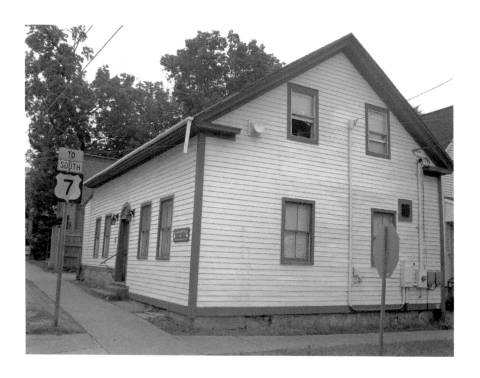

Above: The home of Captains Richard and Lavater White. *Photo by Roger Lewis.*

Left: Steamboat poster featuring Captain Richard W. Sherman. *Image courtesy of Lake Champlain Transportation.*

speculation that the fire was a diversion created by a thief who was hoping to get his hands on a carpetbag of money being transported by a Burlington bank employee. The money *was* stolen, but the thief was found out. He was caught days later by the banker's son, who not only recovered the cash but also gave the lowlife a beating he would not soon forget.

Jahaziel Sherman finally recovered. Richard Sherman went on to become a well-known steamboat captain in his own right. The wreck of the *Phoenix* is still with us, submerged near Colchester Shoal, and is now a historic site. I have heard it does not always sit quietly. Locals say that sometimes, during a full moon, you can look out at Colchester Shoal and see a glimmer on the water, as the ghostly flames of the *Phoenix* change the color of the night sky. It rises, shimmering in the clear night air, and then the orange fades into gold, and the ship disappears under the black waves of Lake Champlain.

Chapter Thirteen

THE HERMIT OF CHAMPLAIN

I love Tarot cards. The colorful decks, featuring a variety of symbolic images, are used for creative visualization, divination, fortune-telling and, sometimes, just for fun. Their use in some form dates back to the Middle Ages, and their icons conjure powerful imagery. There is The Devil, The Empress, The Lovers, The Fool and, one of my favorites, The Hermit.

Ahh, The Hermit. After a long, productive life of building, fighting, failing, succeeding and lighting the way for others, he tires of wrangling the world into submission. The Hermit decides to bow out. His existence is all about resting and organizing his thoughts. He might venture out once in a blue moon on some special mission or critical social errand, but mostly, The Hermit, like the cheese in the old children's song "The Farmer in the Dell," stands alone.

And so it was with Isaac Nye, who was known as "The Hermit of Champlain," and whose modern-day ghost plays a game of "now you see me, now you don't" at the Shanty on the Shore, a restaurant on King and Battery Streets in Burlington, Vermont. The building, despite its cheerful, modern appearance, is one of the oldest structures in Burlington. Isaac Nye was unquestionably its most colorful resident.

Isaac Nye was a productive sort. He made his fortune early, starting a profitable business called Nye & Dinsmore, located at the corner of Church and College Streets in Burlington. Before long, he moved the store to a prime piece of property on Burlington's waterfront that spanned the length of Battery Street from Maple to King. He kept a small store with living

quarters in the back and, from there, maintained his storage and transport business. The townspeople noted his success. His canalboat, named *General Scott*, alone brought in nearly $4,000 in three years.

It didn't seem to bother him (or maybe he didn't know) that people considered him quite peculiar. It was noted that Isaac Nye wasn't interested in the things that interested other men. He didn't belong to any clubs or organizations, didn't frequent taverns and didn't chase women. He did have one hobby: he liked to go to funerals. It was well known in town that whenever someone in Burlington died, Isaac Nye could be seen bringing up the rear in the procession to the cemetery. It didn't matter whether he knew the deceased—more often than not, he didn't—he still would ask Jimmy Fogarty, the Irish boy who became his ward and companion, to hitch a horse to his high-backed wagon so he could ride to the burial ground to pay his last respects.

Nye seemed reasonably content until the Rutland & Burlington Railroad asked to purchase a strip of land about forty feet wide that ran the length of his waterfront property. He said no, but the railroad was persistent and powerful. Its president was Timothy Follett, the man who chartered the first Merchants Bank. He had a lot of friends, most of them in high places. Some of them he had made while he was Vermont's attorney general, a position he was appointed to by the Vermont Supreme Court. When Isaac Nye stalled and rejected offer after offer, a commission was appointed by the court to settle the matter. In the end, Isaac Nye was awarded $1,700 for his parcel, which he stonily refused. The railroad got the land anyway, and Nye's money was deposited in an account in his name at Timothy Follett's bank, right across the street from the property in question.

It was whispered that Isaac Nye grew stranger and stranger by the day. He kept mostly to himself, never speaking unless he was spoken to, and he owned numerous large and expensive wooden masts, lashed together in the water at his dock that he didn't use and wouldn't sell. He was offered large sums of cash for them, but he explained the local children liked to dive from them, and he left them rotting in the water. One morning, in the year Isaac Nye turned forty-four years old, customers who came to his store for supplies found it closed and its windows shuttered. They waited, but day after day, Nye's store did not reopen. People speculated wildly about the turn of events; still, no explanation was given. Later, it was said Nye confided to his brother that business had become "distasteful" to him. He continued to live in a small room in the back of the building. He was more than comfortable financially, and his basic needs were met. An Irish family (unrelated to his

Vintage harbor scene with steamboats, Burlington, Vermont. *Image courtesy of Wikipedia.*

ward, Fogarty) prepared his meals and carried them down to his quarters overlooking the lake. This went on for thirty years.

Then, at the age of seventy-four, Isaac Nye died. It came as no surprise. He had been ill for nearly a year. What *was* surprising, shocking even, was this: He dictated in his will that he be laid on the counter in his store so that people might come to say their last goodbyes. Thirty years of mold and dust greeted the townspeople who filed through the small, dank space to get a good look. Thick cobwebs covered the old merchandise he had refused to sell, with Isaac Nye in the middle of it all. The only light came through the open door. It must have been quite a scene.

How happy I would have been to learn Isaac Nye had been buried in Burlington. After all his visits to the local burial grounds, it would seem a fitting farewell. Alas, his body was taken to Champlain, New York, and buried on family land, a technicality that doesn't keep Isaac from hanging around his old lakeside home.

A waitress who worked at the Shanty on the Shore in the late nineties said she would sometimes have a feeling of being pushed while carrying trays, even though she thought she had a clear path to the table she was serving. A manager at the Shanty during that time also shared a story from one night when he stayed late to take care of some stock and write down additional

Burlington's Shanty on the Shore. *Photo by Roger Lewis.*

instructions for staff because he would be out the next day. While carrying boxes down a flight of stairs, he had the distinct feeling of being bumped into by someone who was climbing the stairs at the same time, particularly creepy since he was the only one in the building.

Footsteps, funny lights and furniture that seems to move by itself have all been reported. My favorite Shanty tale? A vacationing couple who were staying at the Hilton on Battery Street walked over for a late dinner at the Shanty. They went to take a look at the lake afterward. Behind the building, they saw an elderly man in old-fashioned, dark, formal clothing with a tall hat just standing there, staring up at the sky. Before they could approach him, he disappeared.

SPOOKY SIDE STORY

The land underneath the Shanty was once owned by Ira Allen, one of the original proprietors of the city of Burlington. Allen was a surveyor, a key figure in the Revolutionary War and the founder of the University of Vermont (but that's another story). As it turns out, the baby brother of Ethan Allen might have been Vermont's first paranormal investigator as well. In

his papers, he tells of socializing with a family with the surname McIntire: a father, mother and two adult daughters. On one of these visits, he was treated to their tales of ghostly apparitions, including some on their own property, like the frightful spirit of a lady without a head. The next day, with snow on the ground, Ira's hogs got loose, and he was forced to make his way along the McIntire's footpath to retrieve them. It was there in the dark that he encountered the headless old woman they had told him about. "I reasoned to myself is this appearance fictitious or real," he wrote. "If the God of Nature authorises such apperations [*sic*] then there is no flying from them."

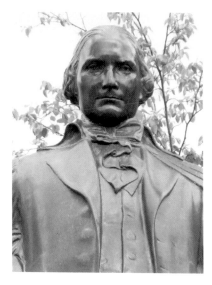

Ira Allen. *Photo by Roger Lewis.*

Wondering if the thing could possibly harm him, he crept closer and readied the staff he had cut to keep the branches from whipping his face, figuring he would use it as a weapon. Finally, once he was close enough to get a good look at his supernatural adversary, he must have breathed a sigh of relief. What had looked like a ragged old woman without a head was nothing but a broken tree stump, its bark stripped away by birds.

I appreciate his efforts. Every ghost tale you can debunk makes the ones you can't that much scarier.

Shanty on the Shore is at 181 Battery Street in Burlington. Do yourself a favor and get the whole-belly clams.

Chapter Fourteen

MORE TERROR IN THE WALK-IN

One morning, while visiting my friends Charlie, Ernie and Lisa on the air at radio station News Talk 620 WVMT, I got an interesting call from a listener. It was a man who had just finished renovating an 1860s farmhouse. According to his story, he had company during the remodel. As he worked, not one but *three* ghostly entities joined him, passing the time while he sawed, drilled and hammered sheetrock.

"What did they want?" I asked.

"I'm not sure," he said. "They were just there. Like they were interested in what I was doing. I wasn't afraid or anything. They were friendly."

"Are you still living in the house?" Charlie asked. The guy said he was. He seemed very proud, as he should be, that he had restored the place down to the smallest historical detail. The only problem was, as he told us, the ghosts were now noticeably absent.

I told him it seemed to me the ghosts had hung around to keep an eye on things. They were attached to the place, and it was only natural that they were curious, or maybe even concerned, about what he might change. "They must be pretty satisfied with your work," I said.

"I guess," the guy agreed. "But I kind of miss them. I was hoping you could tell me how to get them to come back."

A spirit attached to a home may feel threatened by the presence of new owners and any modifications they might make. Ghosts used to be flesh-and-blood people. Some people don't like change. A famous downtown Burlington haunt, for instance, has seen quite a few renovations over the

past few decades. The resulting onslaught of bizarre spirit energy supports the theory that change is not always good.

I'm talking about American Flatbread Company, located at 115 St. Paul Street. If you happen to need a trip to the restaurant bathrooms while you're there and feel a nagging but invisible presence, ignore it. It's probably no one you know. The American Flatbread building was constructed back in 1805 as two stores, with the south half owned by a man named Gideon King.

Gideon King's family was prominent in Burlington's early history. His father owned a tavern on the northeast corner of Water Street, called Battery Street today, and his brother owned an inn and ran the jailhouse on Courthouse Square, the place we call City Hall Park. King's own accomplishments were many. A freemason, he was a key player in Burlington's early government. His knowledge in matters of shipbuilding, lake trade and lake transportation ran far above most. After all, he had acquired his first boat at the age of fourteen.

In the late 1700s and early 1800s, he either owned or owned interest in just about every boat in Burlington's harbor. He owned the docks and stores

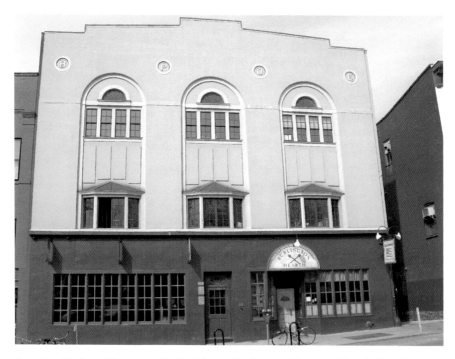

American Flatbread Company, St. Paul Street, Burlington, Vermont. *Photo by Roger Lewis.*

that the goods from those ships were transported to in Burlington, and in Whitehall, New York, too. When Gideon King wanted something to go his way, the usual rules didn't apply. People might not like it, but they listened to the man, who was as bright as he was headstrong.

Customs agent Jabez Penniman knew him to be a formidable adversary. The Embargo Act of 1807 meant that merchants like King were forbidden by federal law to trade with foreign markets, which meant King and his suppliers were losing money. Gideon King became a smuggler on a very large scale, a key figure in John Jacob Astor's fur trade, and he also controlled boats that were ferrying potash, textiles, whiskey, coffee and chocolate along the watery superhighway that was Lake Champlain. Penniman was known to joke about the standoff between Vermont's merchants and the government: "[Gideon] King has not drowned me yet." Still, not everyone turned the other way when it came to the fortified rafts and ships with false hulls that moved goods in the dark of night via Lake Champlain.

So, like many water merchants of that era, King employed a crew of rough locals to make those round trips up and down the lake, men who considered drinking and disrespectful behavior forms of recreation. I think of this when

Gideon King's house, King Street, Burlington. *Photo by Roger Lewis.*

I bring my haunted tours to the alley beside American Flatbread because, according to local legend, it's the kind of behavior the spirits in the building are known for.

Starting as far back as the seventies and with a restaurant called Carbur's, there has been talk of something unsettling in the building at 115 St. Paul and strange incidents that escalated in the early nineties, when a young cook committed suicide. Was his unfortunate act the catalyst for more than a decade of strange occurrences? Or was it a minor renovation that took place around that time? Whatever the reason, the ramped-up activity made everyone uncomfortable, with female servers in the building feeling especially targeted. Women working there reported being unwilling to go to the basement alone, for fear of being slapped, pinched or pushed by someone they couldn't see. One waitress stopped wearing skirts to work after she experienced a mysterious cold draft that blew unexpectedly when she went to retrieve supplies in the basement storage. She said it was so strong that it felt like someone lifting her hem to an indecent level. Some servers hated the basement so much that they were willing to part with a share of their tips to let others fetch supplies for them when it was their turn.

A former bartender at Carbur's recalled one shift where she was all alone in the place in the wee hours of the morning. She had finished her side work and was counting out her bank deposit when she heard a musical sound, like someone running his or her hands under a crystal chandelier. Surprised, she turned to see who was in the room with her. There was no one there, but on the bar were the glasses she had just finished washing minutes before, stacked in a gleaming pyramid.

People aren't shy about their encounters with the ghosts at American Flatbread. Past members of the kitchen and wait staff have taken my tour and have told me afterward they are so relieved they were not the only ones who had issues with the place. Plates flying off shelves, oven temperatures going haywire as if controlled by an unseen "chef" and flashlights that worked above ground that would cut out in the basement are just a few of the weird things I've heard.

A patron named Cy Chapman was visiting the restaurant and excused himself to use the men's room. While there, he was treated to the antics of an invisible someone who kept deliberately opening and closing the door to his stall. A young woman who worked at the Biltmore Grill, a restaurant that was open for a short time after Carbur's, attended one of my tours a few years back. Afterward, she and her fiancé, whom she met while working at the Biltmore, stuck around to chat. There, in the alley right next to American

Flatbread, she told me about the night she, a server and a female bartender working the end of a slow shift all experienced one of the ghosts firsthand.

It was a snowy night, and dinner service had been light, so she seated the few diners she did have in the room near the bar. The storm outside had gained strength and become a blizzard. Before too long, the manager called and said everyone should head for home as soon as possible. There was just one couple in the place, so the bartender told her that she was going to replace a keg as long as she had time, asking the young woman to keep an eye on the bar.

Here's the bartender's version of what happened:

When she got downstairs, she set the tank down to open the door to the walk-in cooler and the lights went out. No big deal, she thought. There was a storm, after all. She figured they had just lost power. She moved to grab what she came for and started to make her way upstairs, but when she stepped inside the cooler, the door slammed closed, as if someone had pushed it with great force. Before she could feel around for the keg she needed, she heard a loud shuffling sound coming from outside the cooler. Someone was down there with her! But how could that be? She pushed the door with her hip, but it wouldn't budge. Taking a step back, she threw her full weight against the door. Still nothing. She went through the possibilities in her mind. The walk-in door was old, and she recalled the hasp, but it was never locked. Could there be someone on the other side of the door trying to block her escape? She fumbled in the darkness for something she could shove against the door. Suddenly, the cooler was filled with a banging noise, the sound of metal on metal. It started slowly but quickly grew faster and louder. She couldn't stand it. Putting her hands over her ears, she began to cry. Who was making that noise? And why hadn't the server come to check on her? She had been stuck down there for nearly a half an hour! As she thought this, there was the sound of something heavy clattering to the floor, more shuffling and then...silence.

With one last effort, the bartender pushed the door. It gave way, and she ran up the stairs and was amazed to see the server calmly washing glasses behind the bar, while the young couple put on their jackets to head out into the cold night.

Neither the server nor the patrons could believe the woman's state. She was wild-eyed, beet red and crying hysterically. They knew she had been gone only a few minutes, but she thought she'd been alone in the basement much longer.

Who or *what* was in the basement? The male customer, who was about six feet, three inches and probably 250 pounds, wasn't leaving until he found out. He and the waitress had no trouble with the lights. They made their way downstairs and walked all around, but there was no one there. But there was something strange by the walk-in. The heavy metal hasp that was normally attached to the door was lying on the floor. It had been broken clean off.

The server's boyfriend, who stayed on at the Biltmore after she left for another job, said that women at one point were advised not to go down to the basement at all. He said the whole restaurant gave him a creepy feeling. "Maybe I'm extra sensitive to this stuff, but if I was working at a task by myself, I always felt like I was being watched," he said. He described other strange things he had experienced in the Biltmore: "One night, a few of us were in the bar after hours, and we kept hearing things in the other room, like men talking in loud voices. We would stop to listen, go in to check it out, but there was no one there. Then we would go back to the bar, and after a while, we'd hear them again. It was crazy."

When Carbur's became the Biltmore Grill, the restaurant's interior was remodeled and was remodeled again when American Flatbread moved in. As with the man and his ghosts in the 1830s farmhouse, the activity seemed to stir up a whole new batch of vibes—in this case, negative, unruly, self-protective vibes. I wondered why, and then, unintentionally, I hit whoever is so guarded about the space with a whammy of my own.

When I interviewed medium and intuitive counselor Nan O'Brien for my last book, *Haunted Burlington*, she lit on some of the more interesting aspects of the building right away, before I could even get the question out of my mouth. The urban legends surrounding Carbur's/Biltmore Grill/Flatbread were all about the unfortunate incident of the suicide in the basement.

"Oh. I'm not getting suicide at all," Nan said, and I stared at her googly-eyed. She tilted her head slightly and said, "I'm getting...pirates? Can that be right?" Early nineteenth-century smugglers. Close enough, Nan. Close enough.

Spreading history is one of my favorite things. Excited to have a whole new piece of the haunted puzzle, I wanted to tell my guests. I began to incorporate what I had learned into our tours just as a change in American Flatbread's outdoor dining also caused us to shift our location slightly.

Talking about smuggling rather than suicide created a reaction I couldn't have predicted. It was directed at my tour guests. A college student on a private tour with ten people (family and roommates) walked away from us during the American Flatbread visit and fell to the ground. As our group,

Alley next to the American Flatbread Company. *Photo by Roger Lewis.*

including her mother, raced to her side, she began to experience what looked like a seizure. While someone called for an ambulance, we asked her mother if she had a history of problems. No. We asked her friends from school, who had spent the day with her, if they'd seen anything unusual, whether she had eaten—all the questions you would ask when trying to figure out what might be wrong. No one could think of anything. While we waited some distance away from where we had been standing during the tour, she sat up, revived. The paramedics came, checked her out and said she was fine. What in the world had happened?

A week later, a man in the back of our group was listening with rapt attention as I talked of Gideon King and his men, of the restaurant basement and its secrets. All of a sudden, he turned sickly pale and staggered over to sit on some steps far from the rest of the group. When I finished my story, he approached the small group that remained to thank me and ask for a photo. He was looking much better. He said he wasn't sure what had happened, but he had suddenly been overwhelmed with chills and felt that if he didn't walk away he was going to be sick.

A professional photographer visiting from out of town joined us one night. In the alley near American Flatbread, as I talked about the secret tunnels and unsettling episodes in the basement, she began to snap photo after photo with her expensive-looking camera. She would take a shot, check her viewfinder, make a disgusted face and shoot again. I tried not to take her expressions personally. At the end of the tour, she was still fiddling with her gear. After the group dispersed, she approached my husband, Roger, and me, holding the camera out to us. "You look so great and spooky in this light. I was trying to get a couple of shots of you in action, but all I got was this stuff. I have no idea what's going on. This has never happened before." I clicked through the photos. There had been no reason for me to feel self-conscious while she photographed me. There was no "me" in these photos, just angry, zig-zagging orange lines or tiny, splashy balls of fire on a pitch black background. *Whoa.*

It took a while to figure it out. Something about where we were standing combined with what I was saying was having a negative effect on guests and, sometimes, on their cameras. It happened again and again—enough times that we began opening the story with a disclaimer so that people, especially people who were sensitive to spirit activity, would know when something was up.

Still, when it comes to that particular building, it's hard to know what to expect. I recently discovered that 115 St. Paul was, for a period of time in the 1800s, used as Burlington's Masonic Temple. Now you know what an *interesting* bunch the Freemasons are. I'll keep you posted.

American Flatbread is located at 115 St. Paul. Try the Punctuated Equilibrium Flatbread with oven-roasted sweet red peppers, kalamata olives, Vermont goat cheese and rosemary. There is a great selection of brews in the taproom, and for teetotalers, there is Rookie's Root Beer, a local favorite.

Chapter Fifteen

IT CAME FROM THE SEA

I'm fortunate to live just a few blocks from Burlington's shore, and I've wondered many times while walking my dog by the water's edge at the crack of dawn if I might catch a glimpse of Champ, Lake Champlain's elusive sea monster. Sadly, I've never been that lucky.

Still, stories of folks who *have* seen Champ date back to precolonial times, when Abenaki tribes described a creature they called "Tatoskok." Explorer Samuel de Champlain claimed to have seen the critter, too, and over the last few centuries, there have been hundreds of Champ sightings on both sides of the lake, more than 130 credible reports in the past few decades alone.

At one point, the legend of Champ was so widespread and so intriguing that P.T. Barnum of Ringling Bros. Barnum and Bailey Circus was willing to pay $20,000 to the person who could capture the serpent and deliver it in a condition "fit for stuffing and mounting." He hoped to include it in his traveling World's Fair Show.

So what is Champ? Many believe that he (or she?), like the legendary Loch Ness Monster, is a cold water–loving relative of the plesiosaur, a creature believed to have become extinct over sixty million years ago. Others guess, based on the evidence available, that Champ might be a mammal called a zeuglodon, a sort of prehistoric whale.

Champ is often described as long and snake-like, dark or black in color, with a head that has been likened to that of a dinosaur or a horse. Some say they have spied small, horn-like ears. If you think it is peculiar that such a

Above, left: Samuel de Champlain. *Image courtesy of Wikipedia.*

Above, right: American showman P.T. Barnum. *Image courtesy of Wikipedia.*

creature could be playing tag with the giant sturgeon in a freshwater lake, consider this: the Iapetus Ocean, an ocean over 500 million years older than the Atlantic, used to flow into what is now the Champlain Basin. Evidence of this sea includes sedimentary rocks found in the Chazy Reef in Isle La Motte, Vermont, and seahorse fossils unearthed by crews excavating before the construction of the old Burlington High School.

Not surprisingly, most Champ sightings occur in warmer months when people are out on the lake fishing or boating or playing on the shores of Lake Champlain. But Champ has been spotted in colder months as well.

Here's a partial list of Champ sightings through the years:

1819: A captain aboard a scow on Bulwagga Bay, Port Henry, New York, sees a "black monster" in the water that he estimates to be over 180 feet long.

1870: A sighting is reported by an entire steamboat full of passengers in Charlotte, Vermont.

1871: Passengers on the steamship *Curlew* claim to see a head and long neck in the waters of Horseshoe Bay that created quite a wake.

1873: Another steamboat full of passengers spots Champ in Dresden, New York.

1883: Local sheriff Nathan H. Mooney reports his sighting of a gigantic water serpent just fifty yards off shore.

1945: Passengers on the SS *Ticonderoga* see Champ cavorting in the middle of the lake.

1977: Champ is seen in a photograph taken by Sandra Mansi. The photo, believed to be authentic, is featured in national magazines.

1984: Eighty-six passengers aboard the *Spirit of Ethan Allen* spot three to five "humps" in the water just off Appletree Point in Burlington, Vermont.

1993: A baby Champ reportedly swims between two female bathers at Button Bay State Park in Ferrisburgh, Vermont.

1995: Champ researcher Dennis Hall of Champ Quest records Champ on video.

2000: Seasonal resident Elizabeth Wilkins reports seeing a long, crocodile-like creature "thirty to forty feet long" in Willsboro Bay, one of sixteen Champ sightings in the year 2000 alone.

2005: An unidentified, underwater creature is caught on video by fishermen Dick Affolter and his stepson Pete Bodette.

Modern Champ sightings sometimes come with videos or photos, but there are only a handful of images of the monster that have yet to be debunked. Landmark among them is a photo taken by a woman named Sandra Mansi.

Plesiosaur, presumed to be an early relative of "Champ." *Image courtesy of copyrightexpired.com.*

On July 5, 1977, Mansi, a Vermonter who was living in Connecticut at the time, was vacationing with her children and fiancé. They had been sightseeing and got out of the car to stretch their legs on the shores of St. Albans Bay. Around noon, Sandra was sitting on an embankment, looking out at the lake, when she saw turbulence on the water. At first, she thought it was a school of fish. Then, what looked like the head and neck of a huge dinosaur-like creature broke the surface of the water. Suddenly, Mansi's fiancé was yelling at the kids to get out of the lake. As he helped Sandra up from the embankment, he handed her the Kodak Instamatic camera they had brought on their trip. Still mesmerized, she snapped the photo that would make history.

Mansi, who has never wanted to use the image for personal gain, threw the developed photo in the family photo album, where it stayed for several years. One day, co-workers planning a trip to Scotland said they hoped they would see the Loch Ness Monster. Sandra told them they didn't have to go that far to see such a creature. She dug up the picture she had taken, which had been tucked behind some wedding photos. One thing led to another, and her hastily snapped lake scenic shot was soon getting a lot of attention. When the *National Enquirer* made her an offer for the picture, she said no and eventually obtained a copyright to ensure no one else would exploit the photo. She plans to transfer ownership of the copyright to the ECHO Lake Aquarium and Science Center in Burlington.

More recently, a website developer named Eric Olsen stirred up the Champ controversy with his own Champ images and a two-minute video he uploaded to the web that quickly became a worldwide sensation. Olsen was walking at sunrise in picturesque Oakledge Park in Burlington, Vermont, on May 31, 2009, when he saw something moving across the water in a cove near the park's small beach area.

Using his cell phone's camera, he silently captured moment after moment of a mysterious-looking creature swimming very close to the shore. Unsure of what he had captured, he posted the video on YouTube and captioned it "Strange Sighting on Lake Champlain." The video shows a head visible one to one and a half feet above the water's surface. A torso, several feet in length, is seen creating a decent wake behind it. Olsen said the creature struck him as something that was long and without much girth. Checking out the YouTube video myself, I noticed something very interesting while examining frame by frame: what seems to be several segments or what could be described by some as "humps" break the surface of the water.

The place where Champ was sighted by Eric Olsen. *Photo by Roger Lewis.*

Some cryptozoologists, like Scott Mardis of Winooski, Vermont, think the video is the best photographic evidence to date of the existence of Champ. Scott has spent some time researching the Champ legend. He says Olsen's video is "very impressive." And while some people who have viewed the photo said they believe the image is a young moose or even a large dog, he thinks the object's movements and size rule that out.

An analysis of the Olsen video was posted by cryptozoologist Loren Coleman on the website Cryptomundo, a place where people interested in creatures like Champ, Bigfoot and the dreaded Chupacabra share their knowledge. Some are quite distinguished in the world of cryptozoology. Using several different factors and reference points to calculate the size of the creature that appears in the video—including the position of Eric Olsen and his camera, his distance from the opposite side of the cove, the size of the buoy visible in the shot and similar photos of the area that use humans for reference regarding scale—whatever *is* in the video is well over six feet in length. There is some speculation due to its size and behavior that this is a juvenile that may have been overwhelmed with curiosity or simply flouting the unwritten laws of its species' survival.

Whether or not you believe there is a giant serpent lurking in the depths of Lake Champlain, one thing is certain: Champ is great for tourism. Like the Loch Ness Monster, he is known to people around the world. Michael Shea, owner of the *Spirit of Ethan Allen* cruise ships, says his business gets postcards from children living in other countries who want to know more about Champ. The critter is a big draw for young and old alike. Port Henry, New York, has a big parade on the first Saturday in August every year that is dedicated to Champ. You can find his image on cards, mugs, T-shirts and key chains. He is even the mascot for Vermont's minor-league baseball team, the Lake Monsters. Champ doesn't make a dime off any of the enterprises that bear his name, but both Vermont and New York offer the creature their support. On April 20, 1982, the Vermont House of Representatives passed Resolution H.R. 19, an order to protect Champ "from any willful act resulting in death, injury or harassment." Within a year, both the New York State Senate and New York State Assembly passed a similar resolution.

If you are on or near Lake Champlain and see a giant, prehistoric-looking head moving above the surface of the water, be sure to take a photo, if you can manage to hold on to your camera. You'll want to do it quietly, though—you wouldn't want to startle what may be Lake Champlain's most famous natural wonder.

Chapter Sixteen

CREATURES OF THE NORTHERN WOODS

S everal years ago, we were traveling with our two preteen girls up Vermont Route 101 to visit friends on Lake Memphremagog. We had a late start, so we figured that we would stop for dinner on the way. We chose a little family place that promised home cooking. Vermont restaurants have long been known for offering delicious seasonal fare grown by local farms, and on that particular August day, the menu had some tempting vegetable sides to choose from. We interrupted the girls' chattering and giggling to let them order first. They slid seamlessly back into their conversation while my husband and I ordered. After he picked his entree, the server asked, "So, you want the sautéed summer squash?" Roger said that sounded great, and she left to take our order to the window. Suddenly, the table was dead quiet. The girls stared me, then at one another, then at Roger. Josie, our youngest, was wide-eyed.

"*What* did she just call you?" Roger and I looked at one another, confused. We didn't know the woman, and our encounter had been nothing out of the ordinary. "What do you mean?" Roger asked. "What did you think she called me?"

Kylie's face slid into a smirk, complete with the lift of one adolescent eyebrow.

"We thought she called you *Sasquatch*," she answered. Sasquatch? Oh! *Summer squash*. As we unraveled the confusion, we all burst out laughing (and a nickname was born).

There may not be a real Bigfoot at *our* house, but sightings of Sasquatch-type creatures are surprisingly widespread in the North Country and

Vermont. The Bigfoot Field Research Organization (BFRO) says the area along the border of Vermont and New York, roughly between Albany north to Crown Point on Lake Champlain, has had sightings dating back to the French and Indian War.

In his journals, explorer Samuel de Champlain described "the Gougou," a creature that would eat humans and even had a pouch to carry them in. So many tribes had told him stories of the hairy man-beast that he thought there must be some truth in their tales. Abenaki legends feature *Gici Awas*, (pronounced "gih-chee ah-wahss"), a monstrous creature that resembled an enormous stiff-legged bear with an oversized head. But unlike the Sasquatch we know today, Gici Awas was hairless, supposedly a result of eating human flesh. We can only hope, as it was in the movie *Harry and the Hendersons*, that this early Bigfoot has evolved to vegetarianism.

As time passed, descriptions of the frightful beast in reports from New York and Vermont began to sound like the images of Sasquatch we are familiar with today, as in this report that appeared in the *New York Times* in October 1879:

POWNAL, VT., Oct. 17—Much excitement prevails among the sportsmen of this vicinity over the story that a wild man was seen on Friday by two young men while hunting in the mountains south of Williamstown. The young men describe the creature as being about five feet high, resembling a man in form and movement, but covered all over with bright red hair, and having a long straggling beard, and with very wild eyes. When first seen, the creature sprang from behind a rocky cliff and started for the woods near by. When mistaking it for a bear or other wild animal, one of the men fired, and, it is thought, wounded it, for with fierce cries of pain and rage, it turned on its assailants, driving them before it at high speed. They lost their guns and ammunition in their flight and dared not return for fear of encountering the strange being.

There is an old story, told many years ago, of a strange animal that had been frequently seen along the range of the Green Mountains and that resembled a man in appearance. But it was so wild that no one could get close enough to tell what it was or where it dwelled. From time to time in the town's early days, hunting parties used to go out in pursuit of it but, in recent years, no trace of it has been seen, and this news report revives the old story of the wildman of the mountains. There is talk of making up a party to go in search of the creature.

Rendering of Bigfoot based on local sightings. *Drawing by Justin Atherton.*

The BRFO website lists Sasquatch sightings in Essex County, New York, going back to the eighties.

On June 25, 1989, three friends were walking down an abandoned railroad bed in Port Henry at about 1:30 a.m. when they heard a hair-raising scream and something that sounded like metal being thrown. It was coming from just over a nearby embankment, in an area they knew was the final resting place for an assortment of junked cars. "What was that?" one of them wondered aloud. The noises stopped abruptly, as though whatever had been making the sound had heard his question. Suddenly, there was the sound of something big, like a bear, crashing through the heavy brush below, headed toward the tracks where they stood.

Before they could think what they might do, it was standing in front of them, looming in the darkness. Two of the boys took off. The last just stood there, stunned, with the creature right in front of him. It was so close that he could hear it breathing—could, in fact, *feel* its breath. The thing had a nasty, boggy smell, like wet peat mixed with rotting skunk.

Coming out of his daze, the boy started running, but the beast was right behind him, gaining fast, feet crunching into the gravel. When he turned onto the paved road near one of the town's more-traveled streets, though, the creature gave up its pursuit. He turned to watch as it receded from view. It was huge, bigger than any man and definitely not a bear.

The next day, in full sunlight, the boys went back to explore the makeshift car lot. They didn't think to look for prints, but they did see something chilling. Earlier in the week, they had noticed one of the cars in particular, a big, 1960s station wagon. When they had seen it, the vehicle had been on its wheels. The day after their encounter with the creature, it was turned over, sitting on its roof. Side panels and bumpers had been ripped from it and were scattered and crumpled, like candy wrappers. They never went back.

A contender for the Champlain Valley's most famous Bigfoot sighting is Whitehall, New York, birthplace of the American navy. The incident occurred on a cold night in February 1982. Two police officers out on patrol came upon a gigantic, hairy creature about seven and a half feet tall, walking upright on a rural stretch of Route 22. Whitehall had been home to Bigfoot sightings for over a century, but officers Paul Bartholomew and Dan Gordon were some of the town's most credible witnesses in modern history. (Officer Gordon, in fact, passed a polygraph test sometime after the incident.) The men spotted the creature walking upright near the side of the road at about 4:30 a.m., but in a flash, it jumped a guardrail on the shoulder of the road and ran with such amazing speed that they had little time to

respond. They jumped out of their cruiser to check out the area over the embankment. Officer Gordon, his revolver drawn, searched the area as best as he could, but the thing had vanished. He later described it as covered with long, mangy, dark brown fur. It had slumped shoulders and poor posture, and its arms swung back and forth in an apelike manner with each stride.

Sasquatch researcher Bill Bran says the area's ecology makes it ripe for sightings. "It's basically a wilderness area all the way back to the Canadian border," he said. Other phenomena have been associated with Bigfoot sightings. Hikers and hunters have reported repetitive "tree knocking" in heavily forested areas, as well as the sound of shrill, mournful cries that are said to be another of the creature's means of communication.

So, what is this thing, this Sasquatch? Is it a missing link? Is it, as some people believe, not of this world?

Some Bigfoot enthusiasts, putting two and two together, say the creature is part of an alien species from outer space and is only visiting. That is why there is never any evidence. It's like the popular Steven Spielberg movie *ET*: These Bigfoot creatures come to Earth, hang out in the woods, take some samples, leave a few footprints. Sometimes, they are accidentally caught on camera, but they eventually get back in their spaceship and fly somewhere far away. They may not travel by themselves. Some reports have spotted Bigfoot critters under the control of some *other* species of alien, beings that are said to descend to Earth and walk about exploring, followed by tall, hair-covered, apelike creatures that seem to be subservient, like pets. (If you are picturing Han Solo and Chewbacca right now, you're not alone.)

If you're a hunter headed to Whitehall hoping to bag a Bigfoot, you can save yourself some trouble. In 2004, the Village Board unanimously approved a resolution warning against "the willful premeditated act of killing" of a Bigfoot, the third municipal body ever to pass an ordinance of its kind. Called the "Dr. Warren L. Cook Sasquatch Protective Ordinance" (after a former professor at Castleton State College in Vermont), it is similar to the ordinance Port Henry passed that protects Lake Champlain's "sea monster," Champ.

Perhaps it's best to follow the advice given to visitors of our national parks: take only pictures, leave only footprints. And, if you happen to see a suspiciously big footprint, you might want to go exploring in the opposite direction.

Chapter Seventeen
ALIEN CROSSING

My friends Alan and Valerie live in a home that overlooks a harbor in Burlington, with a clear view of our neighboring state of New York. It's a sight so spectacular that it's not unusual for them to arrive home to find total strangers standing in their backyard enjoying the scenery. We joke that living there is like being on vacation all year long. Whether the skies are pristine blue or there are storm clouds roiling over the Adirondacks, living near Lake Champlain is a treat.

But it seems humans aren't the only ones who enjoy visiting the shore. Towns in the Lake Champlain Basin, whether in Vermont or New York, seem to see more than their share of peculiar glowing objects hovering in the sky, which is interesting, since researchers believe UFO sightings are more prevalent in areas with open, less mountainous topography.

From the 1907 sighting of an alien probe over downtown Burlington (mere blocks from the ferry docks) to stories of UFOs being spotted over the weapons storage area at Plattsburgh Air Force Base, reports have been endless. And endlessly fascinating.

Forget rumors of an eighteen-level subterranean facility under the old Plattsburgh Air Force Base runway, where conspiracy theorists claim some kind of Nazi business, mind-control experiments and other creepy endeavors were supposedly conducted. There is enough going on above ground to keep a paranormal geek like me grinning for hours.

In September 1955, at Plattsburgh Air Force Base, a nineteen-year-old airman on night duty reported seeing a blue-white flash followed by the

appearance of an elliptical object on the tarmac outside. Frightened, he slammed the door closed, only to have another door flung violently open. A man, taller than the top of the hangar door, leaned inside and peered at the private, who then fainted. When he came to, the being and the object were gone.

In 1961, a teenage boy living in a family neighborhood in Plattsburgh was helping a sergeant who was living off base install a floor shifter in his '57 Chevy. There was a group of guys hanging around, making small talk, when the kid asked the man what kind of work he did. The man chuckled and said, "Son, if I told you, you wouldn't believe me." The boy told the serviceman he had heard that a lot of interesting stuff went on at the base and mentioned stories he'd heard about a silent orange disk that hovered over the ammo bunkers. The man was momentarily wide-eyed and abruptly changed the subject. Soon afterward, he moved. He said it was a routine transfer.

In August 2007, a woman was driving with her fiancé, traveling north on Route 22 from Port Henry, New York, to their home near Westport when she heard him yell, "What the hell was *that*?!" There was a bright light shining through the passenger side of the car, but since she was driving and there was someone behind her, she couldn't see what he was so excited about. "Pull over! *PULL OVER!*" he demanded. She did as he asked and then leaned over him to get a better look. There, beside the road, was what she could only describe as a UFO, emitting a diffused light in the evening mist. As her fiancé began to try to take pictures of the object, which seemed to be suspended noiseless above the ground, it started to come closer. Putting the car in gear, the young woman floored it, driving at top speed toward the next town, about four miles away. That was when she noticed that the thing, which was hovering close to the tops of the trees, appeared to be chasing their car. Despite its slow movement a few moments before, it had no trouble keeping up. It flew over the car. Her first thought was that it was huge; her second, that it would lift them up inside its tremendous bulk. Instead, it passed the car and sped off into the distance. They reached town before they knew it, and when they got home, they had a hard time falling asleep. In the morning, the woman emailed friends, including a cousin in Willsboro, just up Route 22, to recount what had happened. The cousin called her right away. A boy who was working on her farm told her husband that he had seen a UFO the night before. She and her husband had laughed about it until she got the email.

In October 1967, two duck hunters in Philipsburg, Quebec, were waist deep in water in front of their blind, setting out decoys in preparation for their morning hunt. It was about 4:00 a.m., and as they worked, one of them

looked up and said, "Look at the funny ring around the moon tonight." His friend looked up. The night was clear, and the actual moon was visible directly in front of him. He looked back to the object his friend had indicated, a strange circle with a glowing ring around it, which at first glance would look like a full moon. The object hovered in place for a while and then advanced rapidly on the men, stationing itself directly above them.

Grabbing their guns from the boat, they waited and wondered if, rather than hunting ducks, they might have to protect themselves from something that was hunting *them*.

The object remained overhead for five to ten minutes. Then, in what seemed like an instant, it began to disappear, almost dissolving as it headed straight up into the cloudless twilight sky.

On April 21, 1958, the *Burlington Free Press* reported a strange ball of fire in the skies over Winooski, Vermont. The story had a rather eye-catching headline:

"Don't Talk Too Much"
FIREBALL IN SKY BAFFLES AREA, ESPECIALLY COTE

A dazzling ball of fire suspended from a parachute, a red flare, blinking "signal" lights and a burned out area in the Winooski woods remained the ingredients of a puzzling mystery last night. Most baffled of all was Lyman (Shorty) Cote of 65 Pine St., Winooski, athletic trainer at the University of Vermont, who witnessed the entire display.

"I don't know what it was," Cote said last night, "[b]ut I'm sure it was something mighty interesting. The Air Force seemed to think so, too." Col. William Hovde, commanding officer of Ethan Allen Air Force Base, confirmed the Air Force's interest, but claimed an investigation failed to reveal any clues. The unusual sequence of events began shortly before 9:30 p.m. Friday when a fireball, thought to be a meteor, flared brilliantly in the sky northwest of Burlington. Hundreds of persons saw it. But Cote saw more than that. "I was watching TV and noticed this brilliant red fireball when I glanced out through my picture window," he said. "It was falling and all of a sudden appeared to slow down. Then the color turned from red to white and sort of pale blue. It was then that I clearly saw the outline of a parachute. Then it seemed to land in the woods behind Fitzgerald's dairy farm off the Mallet's [sic] Bay road.
It flared up red."
CALLS POLICE

Cote promptly called the Winooski police to notify them. They said they would check with the air base.

A short time later, some Winooski policemen arrived at Cote's house and at their request, he tried to guide them to the spot where the object appeared to have landed.

Capt. Joseph Sprano of the Winooski Police Dept. said a swampy area between Cote's house and the spot they headed for blocked their efforts.

"But I plainly saw two blinking white lights, at the spot Cote was pointing to from his house," Sprano said.

Cote said he was pointing out the spot to the police when a red flare went up and the blinking lights began.

Police said Cote tried in vain until about midnight to find their way to the spot.

On Saturday morning, Cote tried again. This time he was successful. He said he found a scorched spot in the woods, but no signs of life or the parachute.

Later on Saturday, two enlisted men from Ethan Allen Air Force Base paid Cote a visit and he guided them to the spot. "They seemed to know what it was all about, but told me not to talk about it too much," Cote said.

"The sergeant also told me not to touch anything," Cote said.

The two airmen left, but Cote said a helicopter was seen later Saturday "...Hovering just over the treetops."

Hovde confirmed that an Air Force helicopter was sent out to the area, but said it found nothing.

Will File Report

He (Hovde) said he will file a report on the incident with Washington, but added he had no knowledge of what it might have been. He said he had none of his aircraft in the air at the time and did not know of any planes in the vicinity.

The mysterious fireball seen in the skies earlier was confirmed by the CAA tower at the Burlington Municipal Airport.

In 1965, the city of Burlington had a mass sighting of a UFO in the area known as the South End. It came from the east, over Burlington's Pine Street, and danced in the sky over land that used to be the old Foster farm. Lisa Therrien was with her sister, Sylvia, when she saw it in the air over her home on Briggs Street. "It would hover down close, and then rise, then come down low again, flashing these different colored lights." Others in the neighborhood just a few blocks from the lake saw it, too. They said it was eerie how fast it moved. "It couldn't have been a plane or a balloon," Lisa said. "When it took off it was like a shot. Just gone."

According to a *Nashua Telegraph* report from November 5, 1973, September and October of that year were big for UFO sightings in Vermont, especially in the city of St. Albans. Mrs. John Bushey was returning from Burlington when she saw a ball of light come flying out of the sky and over the hood of her car. Her young daughter reported the incident to authorities, and Mrs. Bushey was shaken for a while after. The next month, another St. Albans resident named Louis Mott had a similar experience. On a visit to relatives in town, he and his wife were just getting out of their car when a large red object flew over the top of the house. Searching the sky, they saw two other bright shapes, lit from below, that changed colors in the dark sky. Unlike airplanes, they were silent. As the shapes moved closer toward them, the couple jumped back in their car. The next night, Mott drove to the relatives' house again. The entities put on a repeat performance.

In 2003, in Grand Isle, Vermont, a UFO was spotted by five people (all from the same family) flying low over the lake. Described as very large with one domed light on top and multiple rotating green lights below, it circled multiple times from its position on the lake, traveling around the house and back again. It would noiselessly disappear into the skyline, heading west, only to return, barely skimming a huge willow tree near the home's driveway in one instance. It continued to circle in this way for nearly an hour. While they continued to observe it from just about every window in their house, the mother of the family called a neighbor. The neighbor's daughter asked her to wait just a minute; her mother was busy watching a strange airplane outside the window.

Oakledge Park in Burlington is home to at least one sighting involving Champ, the Lake Champlain sea monster, but locals have also noted strange circular patterns in the grassy fields and in the snow in winter that can't be attributed to any type of grooming device, sled or snow machine. Neighborhood dog walkers say the agriglyphs are large, perfectly symmetrical and, in the case of the winter impressions, appear to have been "melted" into the landscape.

To the north, in Burlington's Lakeside neighborhood, a community created at the turn of the twentieth century for the employees of the old Queen City Cotton Company, people have reported "water UFOs," strange objects that rise up out of the lake and take off at a mind-boggling rate of speed, becoming pinpoints on the horizon in seconds. They're noiseless, unless you count the dripping water. And so far, they seem harmless.

Chapter Eighteen

THE BISHOP'S TALE

Who knew that Lake Champlain, sometimes called the "Sixth Great Lake," was such a magnet for UFO activity? More folks than one would think. New Englanders have a reputation for being a closed-mouth bunch when it comes to the mundane, let alone the unexplainable, but tongues were wagging July 2, 1907, after citizens witnessed the mysterious midair explosion of a cigar-shaped object over Burlington, Vermont. To do the incident justice, I'll turn to the actual newspaper story as it appeared the next day in the *Burlington Free Press*:

JULY 3ᴿᴰ, 1907
SAW BALL OF FIRE
ELECTRICAL DISTURBANCE THAT STARTLED BURLINGTONIANS YESTERDAY NOON
A forerunner to one of the heavy and frequent thunderstorms that have characterized the early summer in this vicinity startled Burlingtonians yesterday just before noon. Without any preliminary disturbance of the atmosphere, there was a sharp report, the like of which is seldom heard. It was much louder in the business portion of the city than elsewhere, and particularly in the vicinity of Church and College Streets. People rushed to the street or to windows to learn what had happened, and when a horse was seen flat in the street in front of the Standard Coal and Ice Company's office, it was the general impression that the animal had been struck by lightning and killed. This theory was not long entertained, as the horse was soon struggling to regain his feet.

Ex-Governor Woodbury and Bishop Michaud were standing on the corner of Church and College Streets in conversation when the report startled them. In talking with a Free Press *man later in the day, Governor Woodbury said his first thought was that an explosion had occurred somewhere in the immediate vicinity, and he turned, expecting to see bricks flying thru the air. Bishop Michaud was facing the east and saw a ball of fire rushing through the air, apparently just east of the National Biscuit Company's building. Alvaro Adsit also saw the ball of fire, as did a young man who was looking out of a window in the Strong Theater Building. Another man with a vivid imagination declared that the ball struck the center of College Street near the Standard Coal and Ice Company's office, knocked the horse down by the jar, and then bounded up again to some undefined point in the sky.*

The unusual disturbance was followed in a few minutes by a downpour of rain, which continued, with brief interruption, for nearly two hours.

Witnesses to the incident also recounted their experiences to Burlington weather forecaster William H. Alexander.

The first eyewitness account is by Father John Michaud, an educated man who was the second bishop of the city, as trusted as the founding bishop, Bishop DeGosbriand. He was hardly a man for telling tales.

I was standing on the corner of Church and College Streets, just in front of the Howard Bank and facing east, engaged in conversation with ex-governor [Alexander] Woodbury and Mr. A.A. Buell, when, without

Church Street intersection, location of the 1907 UFO sighting. *Courtesy of UVM Special Collections.*

The corner of the Howard Bank building. The UFO appeared in the sky to the right. *Photo by Roger Lewis.*

> the slightest indication or warning we were startled by what sounded like a most unusual and terrific explosion, evidently very near by.
>
> Raising my eyes and looking eastward along College Street, I observed a torpedo-shaped body some three hundred feet away, stationary in appearance

and suspended in the air about fifty feet above the tops of the buildings. In size, it was about six feet long and eight inches in diameter, the shell cover having a dark appearance, with here and there tongues of fire issuing from spots on the surface resembling red-hot un-burnished copper.

Although stationary when first noticed, this object soon began to move, rather slowly, and disappeared over Dolan Brothers' store [corner of College and Mechanic Streets] *southward. As it moved, the covering seemed rupturing in places and through these the intensely red flames issued.*

My first impression was that it was some explosive shot from the upper portion of the Hall Furniture Store [corner of College and Center Streets]. *When first seen, it was surrounded by a halo of dim light, some twenty feet in diameter. There was no odor that I am aware of as* [being] *perceptible after the disappearance of the phenomenon, nor was there any damage done, so far as was known to me.*

Although the sky was entirely clear overhead, there was an angry-looking cumulonimbus cloud approaching from the northwest. Otherwise there was absolutely nothing to lead us to expect anything so remarkable. And, strange to say, although the downpour of rain following this phenomenon, perhaps twenty minutes later, lasted at least half an hour, there was no indication of any other flash of lightning or sound of thunder.

Four weeks have passed since the occurrence of this event, but the picture of that scene and the terrific concussion caused by it, are vividly before me, while the crashing sound still rings in my ears. I hope I may never hear or see a similar phenomenon, at least at such "close range."

The next witness interviewed was Alvaro Adsit, well-known Burlington merchant and amateur photographer who in his spare time also liked to build and race sailboats off Thompson's point in Charlotte:

I was standing in my store [Ferguson and Adsit's Store, on the corner of College and Mechanic Streets across from Dolan Brothers–J.T.], *facing the north. My attention was attracted by this "ball of fire" apparently descending toward a point on the opposite side of the street in front of the Hall Furniture Store, when within eighteen or twenty feet of the ground, the ball exploded with a deafening sound. The ball, before the explosion, was apparently eight or ten inches in diameter. The halo of light resulting from the explosion was eight or teen feet in diameter. The light had a yellowish tinge, somewhat like a candle light. No noise or sound was heard before or after the explosion. No damage was done so far as is known to me.*

Governor Woodbury, who had been making conversation with the bishop, said that his first thought was that an explosion had occurred somewhere in the immediate vicinity, and he turned, expecting to see bricks flying through the air. He wasn't the only one. W.P. Dodds was working at the Equitable Life Insurance Company on the south side of College Street. "I saw the 'ball' just before the explosion," he said. "It was moving apparently from the northwest [over the Howard Bank Building] and gradually descending. I did not see it at the moment of the explosion or afterward; no damage resulted so far as known to me."

The noise was loud to cause a disruption of normal activity in the downtown area. Residents, merchants and shoppers rushed to windows and into the street to see what had happened. It was a topic of conversation throughout the summer, as young and old scanned the skies to see if they might spy another strange, fiery, flying object.

It wasn't until August 1, 1907, about a month later, that the U.S. Army Signal Corps established its small Aeronautical Division. It consisted of three people (until one of them deserted, leaving only two) who were tasked with exploring the possibilities of ballooning and dirigibles rather than heavier-than-air flying machines. And it would take two more years

Top: Burlington businessman Alvaro Adsit, witness to 1907 UFO sighting. *Photo courtesy the family of Robert Adsit.*

Bottom: Governor Alexander Woodbury, witness to 1907 UFO sighting. *Photo courtesy of UVM Special Collections.*

before the U.S. government bought the army flyer it contracted for with the Wright brothers.

So what was this UFO? Just a ball of lightning or a malfunctioning alien probe aborted by a larger craft? The case of the exploding airship in downtown Burlington remains a mystery, but I, for one, will keep watching the skies.

Chapter Nineteen

CLOSE ENCOUNTER AT CAMP BUFF LEDGE

As a teenager, I lived in Isla Vista, California, for a while, doing things that would shock my adult self, like slathering my body with a mixture of Vaseline Intensive Care Lotion and Crisco oil to get a deeper tan; skipping school to watch long-haired college boys do tai chi at the overlook on Del Playa Drive; and (I can say it now that I'm too old to be grounded) hitchhiking. One night, while sitting on the beach and watching the fluorescent crests on the waves as they rolled to shore, I nudged my friend who was sitting next to me. "What's that?" I pointed out across the water. In the dark, three bluish-purple lights were lined up vertically above what would have been the horizon line. He looked out to where I was pointing. "Huh. Just an obstruction tower, I guess." I thought for a minute. My stepfather maintained airplanes for a living, and I had grown up around air base runways, but I had never seen a tower like that. Then it hit me. It couldn't be an obstruction tower. First of all, it had not been there before it got dark, and even if it had been, what was it doing so far from shore when the only thing on the other side was miles of ocean? As I started to explain this, something funny happened. Two of the purplish-blue lights moved—one up, one down. They reconfigured themselves to join the third in a horizontal pattern. I grabbed my bag and ran home to tell my stepdad, who went outside to get a good look. The lights were there, and they were moving again, spreading out to make a triangle.

"Are they helicopters?" I asked. He shook his head and said he was calling a buddy who had worked with him at Vandenberg Air Force Base, a missile-

testing site up the coast. He described the lights to the guy along with what I had seen. Because they both raced sprint cars in their spare time, he talked gear-head stuff for a few minutes, and then he hung up. About an hour later, the guy called back.

"Yeah?" my stepdad said. "Hmm. Well, hell, if they say so." He got off the phone.

"What did he say?" I asked.

He smiled. "Officially, there's nothing out there." Except we knew there was.

When a young man named Michael Lapp (not his real name) called astronomer and UFOologist Walter N. Webb on Halloween in 1978 to tell him about *his* experience with a UFO sighting, Webb was tempted to tell him he would just mail him the standard questionnaire. Not only did the fellow's story about the encounter sound too good to be true, but he had waited ten years to tell it. But at some point during their conversation, something about Michael's manner and the tale itself intrigued Webb. His fascination with the subject of UFOs had begun with his own sighting in 1951, and ten years later, in 1961, he had been the primary investigator in the Betty and Barney Hill abduction, one of the more famous UFO cases of our time. Webb had become an expert at close-encounter occurrences, cases that involved observer interaction with the phenomena. As he continued to talk with Michael over the phone, he realized he was hooked.

Michael's story began on the warm, bright summer evening of August 7, 1968. He was spending his vacation from school as a counselor at Buff Ledge, an all-girls' camp on the bay in Colchester, Vermont. The normally bustling camp was quiet; most of the campers, members of the highly competitive swim team, had gone to Burlington for a meet. Michael was sitting with another counselor, a girl named Janet Cornell (also a pseudonym), enjoying a little downtime and some light conversation while taking in the view. As the sun set over the New York side of Lake Champlain, a surprisingly bright light appeared. At first, the two kids thought it might be an especially clear view of Venus, but they weren't sure. Suddenly, the object began to descend. "Wow! Venus is falling!" Michael exclaimed. But as the light moved closer, they noticed it had a distinctly cigar-like shape. After a moment, it dropped three lighted objects that flew with great speed out over the lake. It then disappeared.

According to Janet, the smaller objects had more light than shape and put on a real show, whizzing past them and then flying straight up before eventually dropping down toward the lake. They would then stop abruptly. Sometimes, they would float back and forth as gently as a milkweed parachute.

The UFOs moved closer to the two counselors, pulling themselves into a triangle formation. Michael remembered hearing a sound in the air as they came near the two. It was electric and almost musical, what Mike described as sounding like "a thousand tuning forks." They watched silently as two of the objects pulled back, letting the third UFO pass over them. It went up into the sky, so far up that it disappeared. And then it suddenly plunged back down, submerging itself in the cool waters of the lake. Waves splashed against the dock, a wind came up out of nowhere and animals began to screech and scream up and down the woods on the water's edge.

When the UFO came up out of the water, it moved deliberately toward the two teens seated on the dock. The ship was so close now that Michael and Janet could see two beings through the transparent dome on the top of the craft. Under hypnosis, the two were able to recall that the beings appeared small, almost child-like, and according to Michael's testimony, the creatures were hairless. They had large eyes, which Michael said protruded like racing goggles and were positioned, frog-like, on the margins of their faces. Their heads were large, out of scale with the rest of their bodies and sat atop elongated necks.

For some reason, maybe due to some trick of mind control employed by the creatures, Michael slapped his knee. As he observed the aliens, one of them, looking back, slapped its knee also. The connection made, the ship began to glow. As he looked up, Michael saw ridges and rivets in the bottom of the craft. "A machine!" he thought. "The thing is a machine!" He jumped up to try to grab it, and that is when a beam of blinding light shone down on them. Michael grabbed Janet's arm and pulled her back. The momentum landed both of them face-up on the dock, the ship now hovering over them. Michael recalled screaming, "We don't want to go!" and then praying,

Michael's sketch of the alien ship that he drew while under hypnosis. *Image courtesy of CUFOS.*

"Jesus, protect us." All at once, he and Janet felt the irresistible pull of sleep. Then, they blacked out.

When Michael and Janet awoke, the dock area was totally dark. They could hear shouts and laughter signifying the swim team had arrived back at camp. Over the lake, the UFO had moved higher up into the sky. It flashed its lights in sequence over the course of a few minutes and then suddenly vanished. "How long have we been here?" Michael wondered. Janet seemed to be in a drowsy state, nearly a stupor. She went back to her cabin, and Michael, still groggy, joined a party with some of the other counselors. Neither broached the topic of their encounter for the rest of the summer; in fact, Janet seemed to recall little about it. When the camp closed down at the end of August, the two parted ways. Michael thought about the incident every once in a while, but as time passed, he began to have dreams that seemed too peculiar to have been created by his subconscious mind.

Before that summer in Colchester, Michael hadn't given much thought to UFOs. By the fall of 1978, when he contacted the Center for UFO Studies (CUFOS) and was put in touch with Webb, he was having regular nightmares about his encounter at Buff Ledge. With Michael's cooperation, and Janet's later, Webb was able to use hypnotic regression to find out what happened to them that night at Buff Ledge, unraveling the mystery of the "lost time" the teens had experienced that night. During hypnosis, Michael and Janet remembered being taken onto the ship and could recall their physical examinations. Janet described the cold feel of the table and the pulling sensation as samples were taken of her hair. Lights were held up to her eyes, and something had pinched her neck. She glimpsed enough of the aliens to be able to describe them the same way Michael had. But she said that it was just so weird and that she kept her eyes closed most of the time.

Michael said he watched the creatures examining Janet. Their hands were long, three-fingered and web-like. They took skin and fluid samples. It was Michael's impression that the aliens all looked alike, with those large heads and long necks. From what either of them could see, the creatures had no distinguishable sexual characteristics.

Michael and Janet described being moved through various rooms of the UFO but couldn't recall actually walking from place to place. They both had an image of doors simply opening up in the walls before them and a sensation of floating. They recalled, too, under hypnosis, that one of the beings was on the periphery of the examinations and appeared to be recording data while looking at a wall full of screens or rectangular lights. Their description of the ship was eerily like the close encounter of a nineteen-year-old girl

Michael's sketch of an alien abductor that he drew while under hypnosis. *Image courtesy of CUFOS.*

named Shane Kurtz. She talked of two or three short alien beings who performed various procedures in a succession of white rooms. She noted, "I glided along without their hardly touching me." Her story, documented by parapsychologist Hans Holzer, also involves "missing time." It occurred just three months before the abduction at Buff Ledge, within about 150 miles of the Colchester camp.

As it turns out, August 1968 saw a remarkable amount of UFO activity. And, in an era well before the advent of the Internet, details of the abduction encounters were remarkably similar, the same beam-of-light levitation, same devices used, same amnesia and same description of the alien entities.

The investigation into Michael and Janet's claims lasted a staggering five years. Their background data indicated they were credible witnesses, having no mental illnesses. In their hypnotic interviews, they corroborated one another's recollections of the close encounter. In many ways, Michael and Janet's experience was a classic UFO encounter, but it had one thing other double-witness encounters didn't: two people who knew each other briefly and hadn't seen one another in nearly eleven years telling virtually the same version of their long-repressed story.

Imagining UFO encounters, especially close encounters, is exciting, but people who deal with recording and comparing the details of UFO phenomena on a daily basis don't lead lives as dramatic as the stars of *Men in Black*, nor do they make salaries on par with Will Smith and Tommy Lee Jones.

The Center for UFO Studies was started by Dr. J. Allen Hynek, who served as the astronomical consultant for *Project Blue Book*, one of a series of studies of UFOs conducted by the United States Air Force. Information can be found on its website, CUFOS.org.

CUFOS receives no money from the government. It is privately funded. If you believe in the value of its research, donations can be sent to the following address: CUFOS, Box 31335, Chicago, IL 60631.

Chapter Twenty

BUT WAIT! THERE'S MORE!

PLATTSBURGH AIR FORCE BASE

You might not think there is anything spooky about an abandoned air force base, but at Plattsburgh Air Force Base, reports of swirly orbs, peculiar flashing lights and other strange sights abound. In the Old Barracks, visitors have seen flying orbs and heard the sound of footsteps on the second floor, even though no one is there. Then there is the old Post Cemetery. It is the final resting place of unknown soldiers from the Battle of Plattsburgh, and it is also the burying ground for victims of the Spanish influenza, which killed over 700,000 Americans in 1918. Strange cries are heard from within the grounds, and a female apparition dressed in white is seen eternally searching for her dead baby. Shadowy figures of small, lonely children are also seen, and in the quiet, you can often hear the footsteps of soldiers marching. Some have reported seeing a Revolutionary War–era soldier marching back and forth between the pillars at the main gate, and another figure has been seen standing guard.

Perhaps creepier than the ghost stories are persistent legends of Plattsburgh AFB being the site of mind-control experiments affiliated with Dr. Ewen Cameron, a twentieth-century Scottish-born psychiatrist, thought by some to be a madman. Cameron administered electroshock therapy, experimental drugs and LSD to healthy patients to manipulate their brains. Some did not survive.

There are also rumors that some kind of secret underground testing at the base resulted in the 5.1 magnitude earthquake that occurred on the East Coast the morning of April 20, 2002. The quake damaged foundations, roads and bridges. Tremors were experienced as far west as Cleveland, Ohio. And, if that doesn't shake you up...

MARIE BLAIS

For the longest time, people thought the Cotton Mill Ghost had forgotten about the fateful evening in 1900 when she lost her life in a tragic train accident on the Rutland and Burlington line. The ghost, whose real name was Marie Blais (pronounced "Blay"), had been an employee of the Queen City Cotton Company in the south end of Burlington, Vermont. She lived in the little Lakeside neighborhood the company had built to ensure it would have enough housing for its workers and to attract workers as well. On June 28, Marie, her sister and a good friend, who were all in their early twenties, were returning to work from their dinner break. They had been chatty at dinner and were running a bit late. As they left their home, a summer storm blew in off nearby Lake Champlain, whipping their hair and their skirts and nearly knocking them over. They rushed toward the mill and were about to broach the railroad tracks when they saw the train coming. Thinking that they had plenty of time, they began to cross. Young Marie's companions made it, but she did not. The 6:40 p.m. train hit her, sending her flying seventy-five feet in the air. She was killed instantly. People in the close-knit (mostly French Canadian) neighborhood were crushed, and so were Marie's co-workers and supervisors at the mill. Marie had been a pretty, lively girl, and they missed her terribly. As it turned out, they didn't have to miss her long; people began to see her screaming on the tracks as she had the night she had been killed. Others saw her standing pale and watchful while her old friends worked the looms at the cotton company. It seemed she wanted to make sure they were doing the same careful job she would if she were still alive.

The excitement over the story of Marie Blais' ghost reached such a fever pitch that soon, people were coming from all over to get a look at the apparition. The engineer who was on the train the day she was killed quit his job. Finally, the railroad company constructed an elevated bridge so residents of the Lakeside neighborhood could cross under the tracks without

fear of injury. For the longest time, no one saw or heard Marie Blais. It appeared she was satisfied with the new arrangement.

Then, in about 2006, things began to happen near the old Queen City Cotton Company that had some of the neighbors puzzled. It goes without saying that the Lakeside community has seen some turnover in the hundred years after Marie's accident, but surprisingly, while there are many new residents, some of the homes are in the hands of the descendants whose families owned them in 1900. Someone new to the neighborhood might not know what to make of the sight of a strange, pale young woman walking through the streets late at night; of the grinding noise that sounds like a train coming to a screeching halt; or the mind-shattering shriek that follows. For the natives, the answer was simple: Marie Blais had come home.

HIGHGATE MANOR

Highgate Manor in Highgate, Vermont, has an interesting, multilayered history. Built in 1818 by Captain Steven Keyes, it has long been some of the most tempting bait for the area's amateur and professional paranormal investigators who have encountered apparitions from many different eras. An African American spirit has been seen and is supposedly a ghostly remnant from a time when the manor was the last stop before Canada on the Underground Railroad.

The manor was a vacation destination during the 1940s and had visiting entertainers such as Benny Goodman and gangster Al Capone, who was known to frequent the hidden speakeasy below the manor. Still, the ghostly voices and images of children are the real centerpiece of this haunt. Dr. Henry Baxter, who bought the house in 1870, practiced medicine at Highgate Manor. It is said that many of the young children he treated, including his own, were growing sick and dying of illnesses no one had heard of. Most of Dr. Baxter's children died before the age of ten. The townspeople believed that the good doctor was using the children for medical experiments. Many remain in the house to this day.

BIBLIOGRAPHY

BOOKS

Blow, David, and Lillian Baker Carlisle. *Historic Guide to Burlington Neighborhoods*. Vols. 1–3. Burlington, VT: Chittenden County Historical Society, 1991, 1993 and 2003.

Copeland, Fred. *Lake Champlain: A Guide and Story Handbook*. Rutland, VT: Hobart Stanley, 1958.

Crockett, Walter H. *A History of Lake Champlain*. Burlington, VT: Hobart J. Shanley, 1909.

Millard, James P. *Lake Champlain: Secrets of Crab Island*. South Hero, VT: America's Historic Lakes, 2004.

Sceurman, Mark, and Mark Moran. *Weird Hauntings: True Tales of Ghostly Places*. New York: Sterling Publishing, 2006.

Webb, Walter N. *Encounter at Buff Ledge*. Chicago: Center for UFO Studies, 1994.

ARTICLES

Affuso, Kaitlin. "The Mysteries of McDonough." *Cardinal Points Online*. December 8, 2011. http://www.cardinalpointsonline.com/fuse/the-mysteries-of-macdonough-1.2681866#.T-3f1s3jDhs.

Cody, Kelly. Reader's Forum. *All Points North* (Spring 2005). www.apnmag.com.

Delosh, Amanda. "The Ghost Author." *All Points North* (Spring 2009). http://www.apnmag.com/spring_2009/DeLosh_Cheri%20Profile.php.

Glens Falls Post-Star. "Officers Track Creature." August 30, 1976.

LeBlanc, Deanna. "Bigfoot Sightings Bring Vt National Attention." WCAX TV video, 2:44. April 12, 2012. http://www.wcax.com/story/17402034/bigfoot-sightings-bring-vt-national-attention.

Maerki, Vic. "Don't Talk Too Much." *Burlington Free-Press*, Monday, April 21, 1958.

"NESRA Spring 2005 Sasquatch Field Report, Adirondacks–Whitehall Area, New York." North East Sasquatch Researchers Association. Accessed May 10, 2012. http://www.teamnesra.net/drupal/node/22.

Perry, John. "Sasquatch in New England." http://www.bfro.net/NEWS/newengland.asp.

Plattsburgh Press Republican. "St. John's Stories." June 1983, 1989.

Trainor, Joseph, ed. "UFO Explosion over Burlington, Vermont." *UFO Roundup* 5 (June 6, 2000). Accessed May 23, 2012. http://www.ufoinfo.com/roundup/v05/rnd05_27.shtml.

U.S. Department of the Air Force. *Project Blue Book files*. Washington, D.C.: 1952–1970. Accessed May 13, 2012. www.bluebookarchive.org.

Website for the J. Allen Hynek Center for UFO Studies. Accessed May 3, 2012. www.cufos.org.

About the Author

Para-historian Thea Lewis is the creator and co-owner of Burlington, Vermont's popular haunted tour, Queen City Ghostwalk. *Ghosts and Legends of Lake Champlain* is her second book with The History Press (www.historypress.net). *Haunted Burlington: Spirits of Vermont's Queen City* was released in 2009. A book for children, *There's a Witch in My Sock Drawer!* was published in 2011 (Peapod Press, Exeter, New Hampshire), and Thea is currently at work on a collection of horror fiction. She lives in Burlington with her husband, Roger, three terrific teenagers and a bossy but lovable Rottweiler named Zeus. For more information, visit her websites: www.thealewis.com or www.queencityghostwalk.com.

Visit us at
www.historypress.net
..
This title is also available as an e-book